IMAGES
of America

COUPEVILLE

Cheryl,
Celebrating Coupeville's
history!
Judy Lynn
Kay Foss

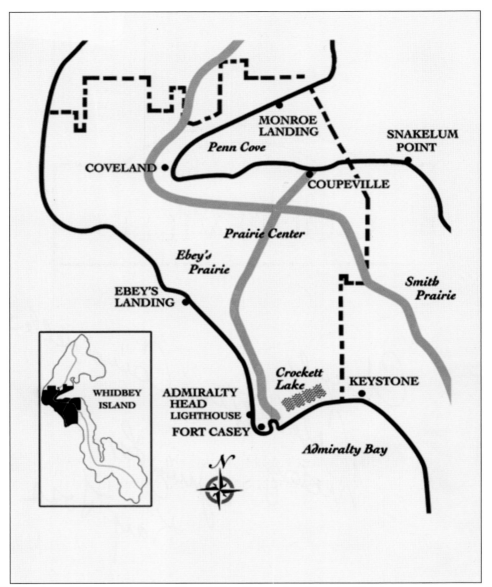

Whidbey Island is located in Puget Sound 30 miles north of Seattle. This book encompasses the central part of the approximately 55-mile-long island with Penn Cove on the east and the Strait of Juan de Fuca on the west. Coupeville can be reached via Deception Pass Bridge on the north and two ferries, one on the south from Mukilteo and another on the west from Port Townsend on the Olympia Peninsula. (Big Rock Designs.)

On the Cover: These "Prairie Pirates" are Whidbey Island farm children pretending to be at sea. Imaginative Burton Engle and chums "set sail" in 1922 for adventures in the *Jolly Roger*. Burton (seated, second from left) was the youngest grandson of pioneers William and Flora Engle; the building in the photograph is William's carriage shed and shop. Donald Nichols is fourth from left, and at the far right is his brother Victor. (DE.)

IMAGES
of America

COUPEVILLE

Judy Lynn, Kay Foss, and the Island
County Historical Society and Museum

ARCADIA
PUBLISHING

Published by Arcadia Publishing
Charleston, South Carolina

Printed in the United States of America

Library of Congress Control Number: 2011935792

For all general information, please contact Arcadia Publishing:
Telephone 843-853-2070
Fax 843-853-0044
E-mail sales@arcadiapublishing.com
For customer service and orders:
Toll-Free 1-888-313-2665

Visit us on the Internet at www.arcadiapublishing.com

*We dedicate this book to all those who have shared their
stories, and in so doing, have kept history alive.*

CONTENTS

ACKNOWLEDGMENTS

Our sincere thanks are extended to all who have made this book possible. Jimmy Jean Cook's book *A Particular Friend, Penn's Cove* offers an important in-depth, comprehensive overview of Coupeville's history.

We are indebted to local historian Roger Sherman. His knowledge of the shipping, farming, cemetery, and church histories of Central Whidbey was invaluable. His research in the writing and photograph selection process is deeply appreciated.

Thanks go also to Steve Kobylk for photographs and for sharing his knowledge of Fort Casey history.

Thanks to Sandra Moore for sharing her father, Harry Moore's, research of Master Joseph Whidbey.

Thank you to pioneer descendants who generously shared their time and memories, including Lillian Dean Huffstetler, Leone "Sis" Willard Argent, Elizabeth Hancock, Lyla Libbey Snover, Joanne Engle Brown, Diane Eelkema, Muriel Pickard, Ilah Lindsay Engom, Georgie Smith, David Engle, Bob Cushen, Ron Van Dyk, Jean Sherman, Carol Thrailkill, and Freeman Boyer.

Without the encouragement and support of Rick Castellano, Island County Historical Society (ICHS) Museum executive director, and the museum's photography collection, this book would never have been published. Visit www.islandhistory.org for more information about the ICHS.

We appreciate Ebey's Landing National Historical Reserve and the National Park Service for making available their photographic collections and for the loan of equipment. Visit www.nps.gov for more information.

Special thanks go to the many individuals who checked the historical facts.

Janet Enzmann's dedication to organizing the archives at the Island County Historical Society until her death in 2010 is deeply appreciated.

Appreciation also goes to Arcadia Publishing editor Donna Libert for her guidance and support.

A special thank-you to Theresa Trebon for editing and to proofreaders Madelyn van der Hoogt, Rowena Williamson, and Cheryl Bradkin.

In addition to photograph credits as indicated in the text, images are also courtesy of sources abbreviated as follows: Leone Argent (LA), Joanne Engle Brown (JEB), Bob Cushen (BC), Peggy Darst (PD), Ebey's Landing National Historical Reserve (ELNHR), David Engle (DE), Ilah Engom (IE), Elizabeth Hancock (EH), Lillian Huffstettler (LH), Island County Historical Society (ICHS), Steve Kobylk collection (SK), Muriel Pickard (MP), National Park Service (NPS), Roger Sherman collection (RS), Georgie Smith (GS), and University of Washington Library Special Collections (UWLSC).

INTRODUCTION

Together, the beauty and natural resources of Central Whidbey Island were the foundation of Coupeville's history long before the town existed. A gentle climate, wide variety of food, and easy access to trees to build longhouses and canoes had eons ago caused natives to build villages around Penn Cove. Farming, logging, and fishing later tempted adventurous and adaptable souls to Whidbey Island's prairies and forests. They founded Coupeville in 1853, making it the second town founded in Washington State.

Ancient natural forces were extremely benevolent when creating Whidbey Island. Approximately 14,000 years ago, the retreating Vashon Glacier dug out Puget Sound and deposited large amounts of glacial moraine on what would become Whidbey Island. These deposits and decayed vegetation from glacial lakes created the rich soil of the prairies near Coupeville.

For over 9,000 years, groups of Native Americans lived in wooden longhouses on Penn Cove. The village site where Coupeville is today was called Butsadsalee (bah-TSAHD-ah-lee), or "snake place." These tribes crafted strong baskets, built cedar canoes, practiced a tradition of status according to the accumulation and redistribution of wealth, and ate deer, smelt, elk, camas roots, clams, mussels, and salmon. A common description of the area's wealth of foodstuffs was, "When the tide is out, the table is set." By the early 1900s, most Whidbey Island natives had relocated to the Swinomish Reservation in La Conner, which was set aside for Indians in that region by the Point Elliott Treaty of 1855.

Capt. George Vancouver reached Whidbey Island as part of a British exploration of the Pacific Northwest in 1792. The island was named for Joseph Whidbey, master of the expedition's flagship HMS *Discovery*. It was one of Whidbey's many survey expeditions that brought him to Penn Cove and Admiralty Inlet. Vancouver would later describe the area around Penn Cove as "the finest we had yet met with." According to a much later description, Penn Cove was "the most beautiful harbor on the Sound . . . so well protected as to be entirely free from the effects of storms and gales, [making] it absolutely safe for vessels to anchor in." Local historian Jimmie Jean Cook concluded early in her research that the people who settled Coupeville "were a pretty sophisticated bunch." Sea captains especially saw possibilities in the sheltered cove and townsite, and most government officials of the mid- to late 19th century visited Coupeville.

In this volume, readers will notice that the name *Whidbey* is sometimes spelled without the *e*. The confusion about the spelling might have originated with the first lighthouse keeper, William Robertson, who spelled the name without an *e*. As far back as 1801, Captain Vancouver's expedition financier referred to "Mr. Whidby." *Joseph Whidbey* is the spelling at his burial site in England. *Whidbey* became the official spelling for the island in the late 1940s.

Whidbey Island's first settler, Thomas Glasgow, did not remain on his property above Admiralty Inlet for long. In 1848, he was warned that a large group of natives was gathering for a tribal meeting on Central Whidbey to discuss the incursion of white settlers, and facing possible violence, Glasgow fled to Olympia. Virginian Samuel Hancock glimpsed Whidbey's shore in 1849, calling it an area that "would become a prominent agricultural part of the territory." He returned in 1852 to farm on Crockett Prairie, along with an onslaught of settlers prompted by the Donation Land Claim Act of 1850.

To reach Whidbey, many courageous settlers completed an overland trek using the Oregon Trail or made a perilous journey by ship around Cape Horn. Others lived elsewhere before ending up near Coupeville: in the 1850s, they came from the California goldfields, San Francisco, or the burgeoning city of Seattle; in the 1890s, settlers traveled from the Klondike goldfields. After working on the transcontinental railroad or in the mines, Chinese laborers came for jobs offered by local farmers.

Once here, settlers used their talents to become farmers, merchants, land speculators, lawyers, doctors, loggers, boat builders, and government officials. Their spirit and determination created

a town able to withstand the vagaries of fortune, and they adapted in ways that fostered continuous development.

It did not take long before increasing settlement created a need for community institutions such as churches (one founded as early as 1853), schools (including the first school of higher learning in the Puget Sound region), and service clubs (such as the Woman's Christian Temperance Union, which publicized liquor's "evils"). After Coupeville was selected as the seat of Island County in 1881, residents established a library on Front Street, and telephone service came to town.

There were times in Coupeville's history when the passion and hard work of its people determined the success of its development. In 1942, a group of local women prodded the US government to give the town a surplus building from the construction of the Grand Coulee Dam; the building became a USO hall, then Coupeville Recreation Hall. In 1979, longtime Ebey's Prairie farmer Wilbur Sherman led a group of church members in building an addition onto the 1893 Methodist Church. He even orchestrated the retrieval of lumber that had floated ashore on Ebey's Landing from a wrecked barge and used it in the construction.

Around the turn of the 19th century and into the 20th century, community leaders realized that the beauty and recreational possibilities of Central Whidbey Island and Coupeville would lure visitors if promoted. In 1901 with those many possibilities in mind, Judge Lester Still built the Whid-Isle Inn at the western end of Penn Cove. Fishing camps also brought sportsmen and their families to the island.

From 1930 through 1942, Coupeville merchants extended an invitation each summer to Indian tribes from Washington, Idaho, and British Columbia to compete in the Coupeville Water Festival. The event drew thousands of tourists and their dollars to the community and afforded Native Americans an opportunity to practice cultural ways without fear of reprisal. Canoe races, games for children and adults, a Ferris wheel, and a parade featuring festival royalty made for a fun-filled three-day event. The last of the original Water Festivals was held in 1942 before being suspended because of World War II. The festival was revived as a one-day event in 1992.

In the mid-1950s, Coupeville's Front Street faced an uncertain future after several businesses, including the post office, pharmacy, grocery store, and a bank, closed their doors to relocate to Main Street. The shuttered buildings and lack of shoppers caused merchants and city officials to wonder how to bring both residents and visitors back to downtown.

In the early 1960s, it took a crisis to force residents into action. The historic downtown buildings were threatened with demolition, and the remaining Front Street merchants realized that only immediate action would save them. The newly formed Front Street Development Association assessed owners for paint and other materials to spruce up the street in time for the first Coupeville Arts and Crafts Festival in 1964. That first year featured arts-and-crafts booths, an art gallery, home-baked pies, and sunny weather. The "Festival" is one of the oldest arts-and-crafts fairs in Washington State, and the second weekend in August nearly always promises good weather.

Funds from the Festival's first years were used to purchase the Alexander Blockhouse and save, improve, and beautify buildings on Front Street. Today, money from every Festival is given as grants to community organizations, and Coupeville's downtown thrives for local residents and visitors.

In the late 1970s, the threat of development of the upper farmland overlooking Ebey's Prairie galvanized Central Whidbey residents into exploring ways to preserve the historic landscape. Through public input along with federal, state, and local government agreement and financing and the cooperation of prairie farmers, Ebey's Landing National Historical Reserve, the first and only one of its kind in the nation, came into being in 1978. This has allowed the farms and prairie to remain much as they have been since the 1890s. From the bluff and ridge trails and Sunnyside Cemetery, the hedgerows that mark boundaries between the 1850s Donation Land Claims are still visible.

Coupeville remains a small town with historic shops serving customers and Victorian houses sheltering visitors and local families. Today, the moderate climate, the bounty of land and sea, and the beautiful topography continue to amaze visitors and inhabitants alike.

One

CANOE PEOPLE

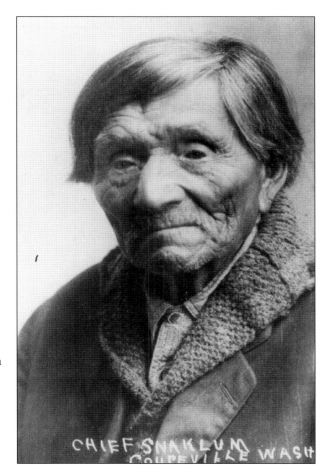

At the time Lower Skagit Indian Charlie Snakelum was born, four Lower Skagit Villages were situated on Penn Cove with their members fishing, hunting, and gathering. Charlie Snakelum witnessed the signing of the Port Elliott Treaty as a youngster and was a frequent visitor to the Swinomish Reservation in La Conner. Local historian Mickey Clark recalled, "Charlie was a fine worker for local farmers, hoeing potatoes, shearing sheep. He was a real nice guy." (ICHS.)

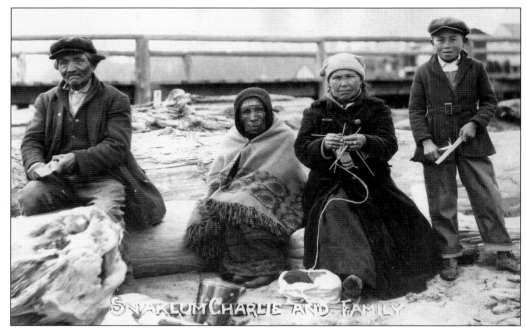

Charlie Snakelum and family lived in a longhouse at Snakelum Point, south of Coupeville, until his death in 1932. Charlie's ancestors were leaders in the Lower Skagit community. Pictured from left to right are Charlie and his second wife, Mary, Mary Jim, and her son August. Coupeville resident Herb Pickard recalled hauling in a net full of salmon with Charlie for a beach salmon bake as a teenager in 1925. August Jim died at age 14 of tuberculosis, as did many young Indians. (ICHS.)

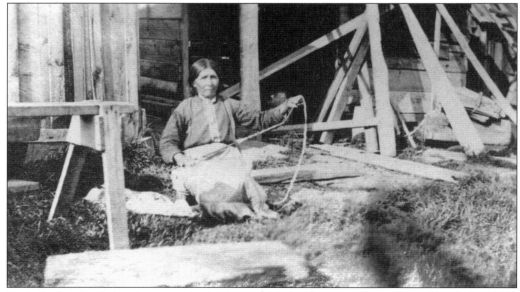

Katie Barlow Snakelum is pictured spinning wool at her home on Penn Cove. She died in 1931 and is buried near the Squi-qui potlatch house near San de Fuca. (ICHS.)

Billy Squi-qui Barlow, the son of Squi-qui who signed the Port Elliott Treaty, was reportedly a religious man and believed honesty was the path to heaven. He may be pointing to heaven in this photograph taken on Front Street in the late 1800s or early 1900s. Billy and his wife, Katie, lived near San de Fuca. After Billy's death, Katie married Charlie Snakelum. (ICHS.)

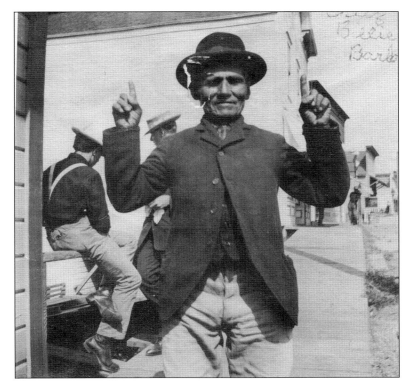

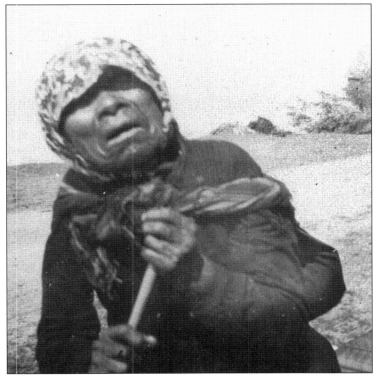

Whilatea was the daughter of S'deh-ap-kan, a signer of the Port Elliott Treaty. She was born in the Lower Skagit village of Butsadsalee on the beach of present-day Coupeville. As an elder, she earned income by gathering clams and selling them for 10¢ a bucket. She lived with her daughter Susie Kettle and Susie's husband, Alex, in a home built for them by townspeople in 1909. Whilatea, called "Squinty" by town residents because of her poor eyesight, died in 1916. (ICHS.)

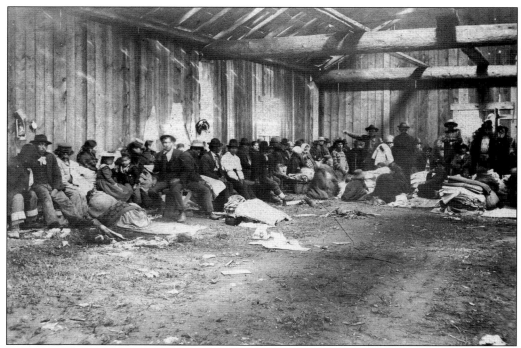

In Native cultures of the Northwest, Indians demonstrated their status and affluence by gift-giving at elaborate ceremonial gatherings called potlatches. The quantity, quality, and frequency of giving symbolized the wealth of the individual or family and created interdependent relationships. The above photograph taken by C.H. Stackpole shows an interior view of the last known potlatch, which was hosted by "Chief" Billy Barlow in 1904 and attended by 300 people. Calista Kinney Lovejoy was a guest of honor. The photograph below, taken by Ernest Hancock, shows boats and the exterior of the potlatch house on the north side of Penn Cove. (Both, ICHS.)

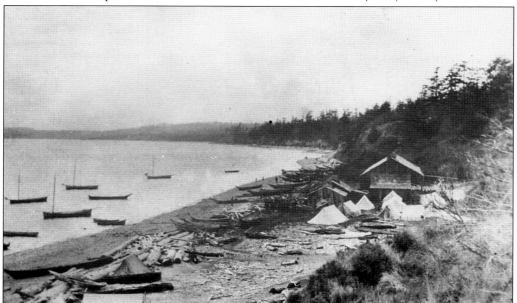

Two

BY LAND AND BY SEA

Capt. Thomas Coupe
arrived on Whidbey
on October 12, 1852.
He skippered the brig
J.S. Cabot and brought
with him William B.
Engle, Robert Hill, and
his sons. Coupe settled
on Whidbey in 1853,
telling his wife that if she
would remain there, he
would give up the sea.
He eventually kept his
word and gave up offshore
sailing but continued
sailing routes in Puget
Sound. Coupeville was
named for the captain,
who is remembered
as the first to sail a
square-rigger through
Deception Pass. (ICHS.)

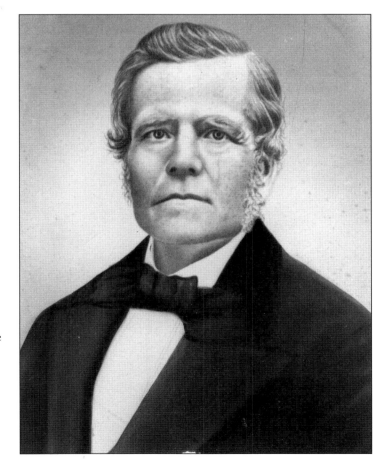

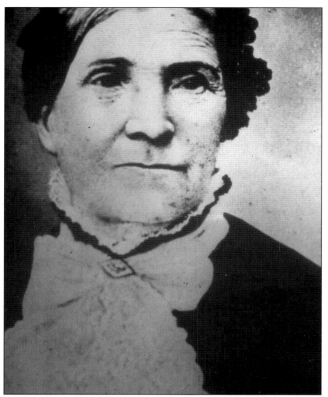

In 1853, Maria Coupe and her children traveled from New England by ship around Cape Horn to San Francisco, where her husband, Thomas, met his family and brought them by ship to their new home. They had six children; Keturah was the first white girl born here. The Coupes' Donation Land Claim stretched from the Penn Cove waterfront to Prairie Center. They donated land for the school and Methodist Church. (ICHS.)

Captain Coupe erected a small log cabin in 1853 on the south side of Penn Cove. His shipping business was so good that in 1854 or 1855, he replaced the cabin with a frame house built for about $125. The house still stands in Coupeville, although moved back from the water. The black walnut tree he planted behind the house still stands as well. (ICHS.)

Capt. James Henry Swift was born in 1816 and left his home in Massachusetts to become a cabin boy in the whaling trade. He came to Penn Cove in 1852 and was the first Northwest captain to carry a cargo of spars from Puget Sound to France. After retiring in 1863, he purchased a farm, served as pilot commissioner for Washington Territory, and served in the Territorial Legislature. (ICHS.)

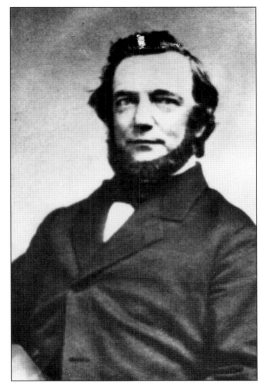

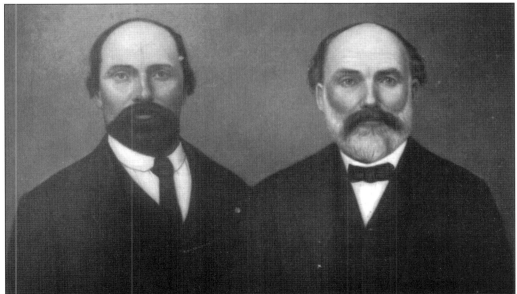

This portrait is of Capt. Thomas F. Kinney and his father, Capt. Simeon Bartlett Kinney. Capt. Thomas Kinney was born in Boston in 1829. He first sailed with his father when he was seven and became his mate at age 19. Thomas eventually settled with his wife, Mary, in Coupeville in a modest home that still stands on east Front Street. He is the brother of Calista Kinney Lovejoy Leach and father of Julia Kinney Hancock, both Coupeville pioneers. (EH.)

Capt. Howard Bentley Lovejoy was the first ship's pilot on Puget Sound and was well respected. He was born in Maine in 1827 and came to Penn Cove in 1853 to ship spars to San Francisco. He married Calista Kinney, and they had six children. Pictured here is his son Howard Bartlett (H.B.) Lovejoy, who owned the Coupeville Boat Works and sawmill and designed and built many fine Victorian homes in Coupeville. (EH.)

Shown at his boatyard, Howard Bartlett (H.B.) Lovejoy (far left) is supervising the building of the *Lt. George M. Harris*. Besides five Mosquito Fleet steamers, he and his younger brother Edwin O. (E.O.) Lovejoy built several private sailing yachts. The brothers also founded the Island Transportation Company, which operated from Whidbey Island to Everett and Seattle. The boatyard office has been preserved, moved, and refurbished, and sits two blocks southeast of its original site. (ICHS.)

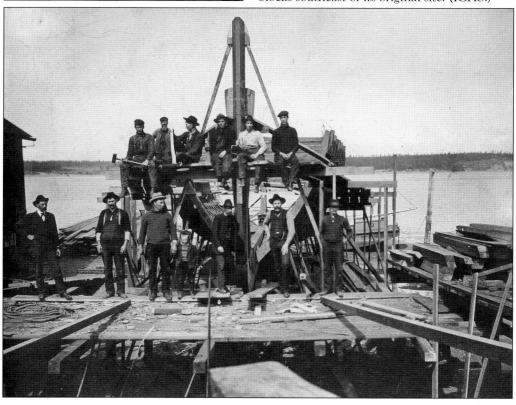

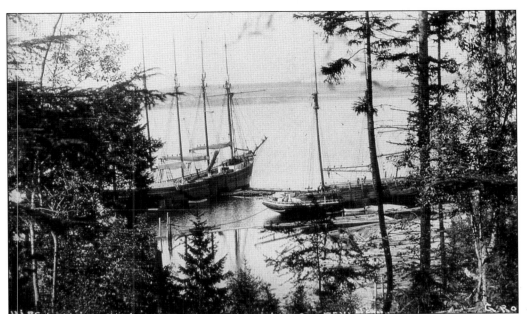

In the 1850s, sailing vessels began visiting Puget Sound, where their captains found forests of Douglas fir. There was a strong demand for lumber for docks, buildings, and mines in San Francisco; lumber for masts was shipped as far as England. This photograph shows mining props (for bracing mine roofs) being loaded at Snakelum Point, east of Coupeville. Commercial sailing ships disappeared by the 1920s after steam power replaced sailing. (ELNHR.)

Romantic WHIDBY ISLAND!

Whidby Island Ferry Lines
General Office
MAin 2222 Colman Dock
SEATTLE, WASHINGTON

As early as 1900, Whidbey Island was promoting itself as a tourist destination. An early-20th-century issue of the *Island County Times* editorialized, "Summer excursionists and tourists are coming to appreciate the island for its hospitable homes, its beautiful woods, fine bicycle paths, and most of all, for beaches." Around that time, the Island County Chamber of Commerce published a brochure entitled *Island County, Washington, A World Beater.* (ELNHR.)

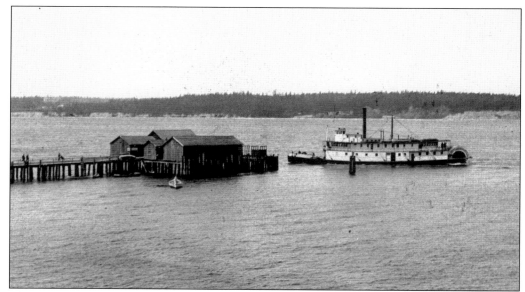

The *Fairhaven*, a 130-foot Mosquito Fleet paddle wheeler, pulls up to the Robertson dock in the 1890s. The *Fairhaven*, built in 1889, ran the Whidbey-La Conner-Everett-Seattle route until replaced by the *Camano* in 1906. The dock joined Front Street on the west side of Whidbey Mercantile (currently Toby's Tavern) and was used until 1905 when the new wharf was completed. Until the Deception Pass Bridge was built in 1935, the Mosquito Fleet vessels were the only mode of transportation for people and supplies. (ICHS.)

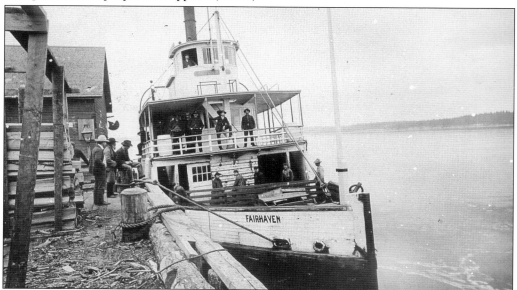

Known as the wharf, this Coupeville pier and dock was built in 1905 and still exists. Elmer Calhoun purchased it in 1914. Supplying fuel for wood-burning steamboats was one of its functions. Many young men earned money cutting wood for the stern wheeler *Fairhaven*. After steamers converted to oil, a fuel depot was built by the E&E Oil Company in Coupeville, and a fuel barge stopped regularly. Calhoun operated the wharf until 1949, which was 13 years after the daily steamboat discontinued the Whidbey route. (ICHS.)

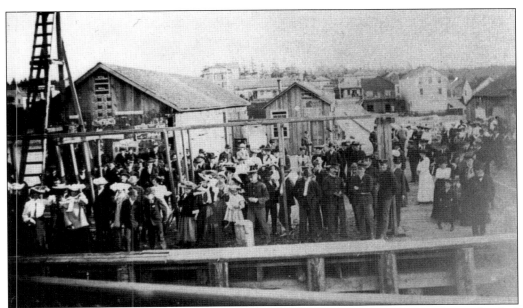

The Coupeville wharves were daily gathering places where locals met friends, got news, and picked up mail. Children loved the excitement and begged their parents to take them to meet the boats. William T. Howard, editor-owner of the *Island County Times* in 1915, met one of the Mosquito Fleet boats daily to get the latest off-island news. The photograph above shows people waiting on the Robertson Dock, perhaps for the McMannus Circus around 1906. In the photograph below, Mosquito Fleet passengers return home to the Coupeville pier after a trip to the big city. A postcard sent by Julia Hancock from Seattle to her family in the early 1900s instructed them to "Meet the *Fairhaven* Monday with the double rig," to bring home her shopping treasures. (Above, ICHS; below, NPS.)

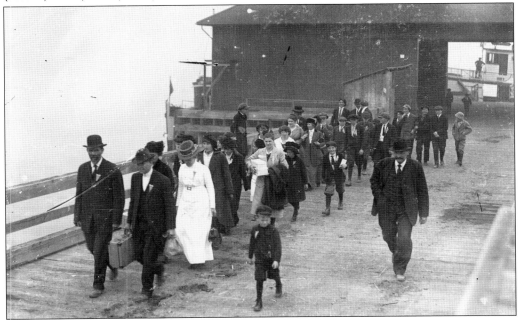

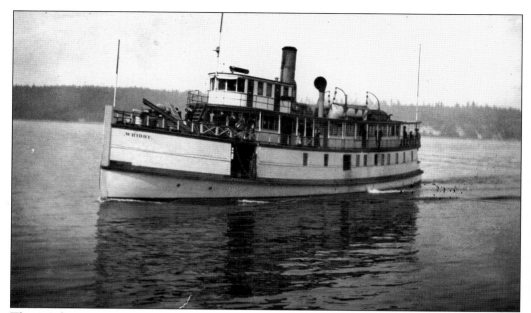

The 110-foot steamer *Whidby* (see reference to the spelling of *Whidby* in the introduction) was built in 1907 by the Lovejoy Boat Works in Coupeville. Steamers moored overnight in Oak Harbor and departed each morning, stopping at San de Fuca on their way to Coupeville, then traveling south to Greenbank and Saratoga, east to Camano Island (if the flag was up), on to Langley, and finally to Clinton. Glendale and Possession Point were the final stops before continuing to Seattle. (ICHS.)

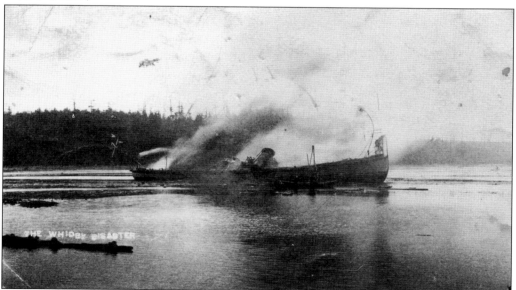

On May 8, 1911, Capt. Henry Arnold moored the *Whidby* in Oak Harbor. He spent the night at home with his family, while two indigent seamen stayed aboard. When the *Whidby* later caught fire, it was cut loose to save the wharf, but the two seamen died and are buried in Coupeville's Sunnyside Cemetery. The engine and boiler were salvaged and placed in the *Calista,* the *Whidby*'s replacement. (LH.)

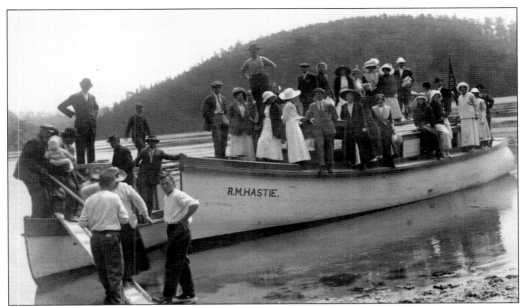

The *R.M. Hastie* was built in Coupeville in 1915 by John "Happy Jack" Komadina. His 25- to 35-foot launches were built on a stub pier east of the Gillespie Livery stable. Boats were launched by sliding them down two poles. Komadina had a sideline of fishing with a net from the wharf. In 1923, a storm came up, and he died trying to save his net. (RS.)

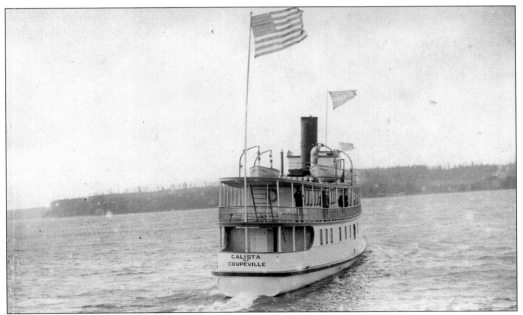

The Mosquito Fleet consisted of 2,500 privately owned vessels that traversed Puget Sound waters between the 1880s and 1935 when the Deception Pass Bridge was opened. One of these steamships was the *Calista*, named for Calista Kinney Lovejoy Leach and built in 1911. She served the Coupeville-Seattle route until July 1922 when she was rammed by a Japanese freighter five nautical miles from Seattle. She sank in 28 minutes, but all 75 people aboard were rescued. (ICHS.)

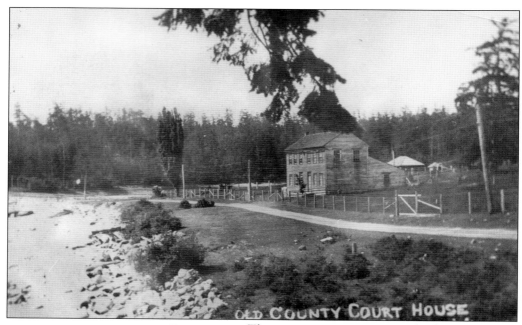

OLD COUNTY COURT HOUSE

This two-story structure was built in Coveland in 1855 by Thomas Cranney and Lawrence Grennan and served as general store, county offices, and courthouse. Cranney was appointed the first postmaster in 1857. By the 1870s, Coveland at the west end of Penn Cove had stores, social societies, and a post office. Court and county offices were moved to Coupeville in 1880, and the courthouse, the second oldest public building in the state, became a private residence. (ICHS.)

Coveland was the first settlement on Penn Cove. The area's first general stores, government offices, and a gristmill were located there. John Alexander and his wife, Frances, claimed a parcel of land, and he started his general merchandise business soon after arriving in 1852. In 1853, Coveland was named the Island County seat of government. Rebecca Ebey's 1853 diary mentions "one store at Coveland." (ICHS.)

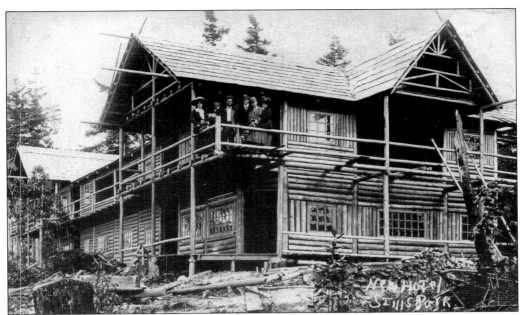

Local Coveland residents began catering to visitors' needs in the early 1900s. Judge Lester Still bought land along Penn Cove in Coveland to develop Still's Park and had Pete Solid build the two-story Whid-Isle Inn by 1900. The building was made of fir logs and became a popular resort for people from the mainland who wanted to spend their vacations boating, fishing, swimming, and strolling through the woods. Local resident Leone "Sis" Willard Argent remembers the judge and the dances held at the pavilion: "In the 1930s, I attended dances in a circular building with the orchestra in the middle. We danced around the orchestra. Judge Still would always give a speech." The Whid-Isle Inn, which once served as a general store, post office, and girls' school, is now known as the Captain Whidbey Inn. (Above, RS; below, ICHS.)

In 1850, Whidbey lawyer and territorial legislator Isaac Neff Ebey traveled overland from Missouri to be the first to claim land under the Donation Land Act. Between 1851 and 1854, he and Samuel Black Crockett convinced nearly 30 family members and friends to join them. Isaac's wife, Rebecca, and sons Easton and Jacob arrived in 1852. Rebecca died of tuberculosis in 1853, four months after the birth of daughter Hettie. On August 11, 1857, Northern Kake Indians from Kupreanof Island, Alaska, shot and beheaded Ebey at his home above Ebey's Landing as revenge for the 1856 killing of their chief at Port Gamble by US naval forces. In 1859, Capt. Charles Dodd, of the Hudson's Bay Company, traded goods with the natives for Ebey's scalp and facilitated its return to the Ebey family on Whidbey Island. At the time of his death, Ebey wielded significant political influence and was thought to be a potential candidate for territorial governor. His murder shocked the Puget Sound region. (LA.)

At center left is Perego's Lake, named for George Washington Perego, who served in numerous armed conflicts, including the Seminole, Mexican-American, and Civil Wars. He lived reclusively with his chickens in a cabin on the beach at Ebey's Landing until his death in 1901 or 1902. (ELNHR.)

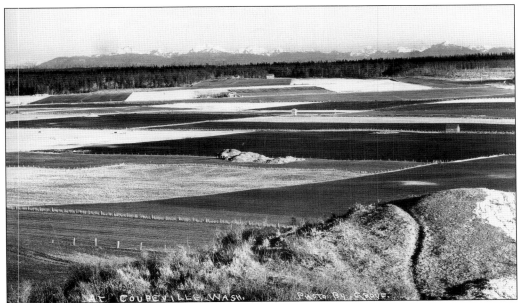

Surrounded by deep forests, the gently rolling Ebey's Prairie and nearby Crockett Prairie were the choice of early settlers such as the Ebeys, Engles, Hancocks, and Crocketts, who wanted to farm. Not long after its original settlement, a patchwork quilt of crops stretched to the horizon. Pioneer Alanson Warner Arnold, great-grandfather of past cemetery commissioner Valerie Arnold, described the view over the prairie in 1865: "Looking south was a valley of some two thousand acres with now and then a farmhouse near the willow groves that dotted the prairie, all bordered with evergreen forests. On the east was the water of Saratoga Passage backed by the Cascade Mountains. On the west the Straits of Admiralty and the Olympics, while to the south, towering above them all, stood giant Rainier looking down on this garden spot of Puget Sound." (Above, DE; below, NPS.)

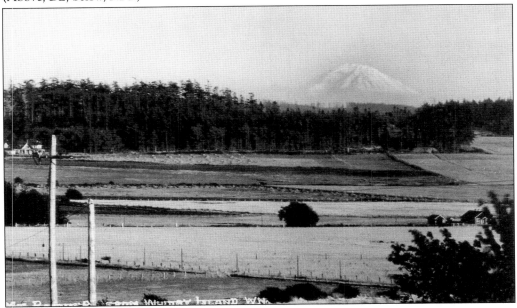

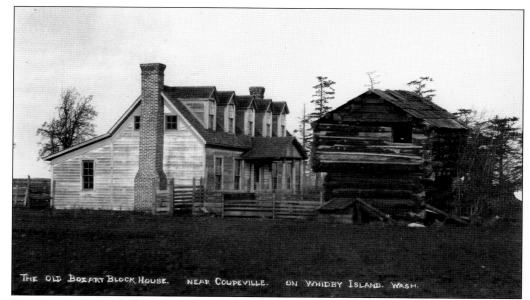

THE OLD BOZART BLOCK HOUSE. NEAR COUPEVILLE. ON WHIDBY ISLAND. WASH.

Upon arriving on Whidbey in 1854, Isaac Ebey's parents, Jacob and Sarah Ebey, set to work clearing land and constructing a home on the ridge to the west of Isaac's home near Ebey's Landing. After the house was built, dormer windows were added, then later removed. The current building may be a reconstruction from the 1880s using materials from the original home. Isaac's brother Winfield had a law office in the blockhouse, which was built about 1856 and later reconstructed. (ICHS.)

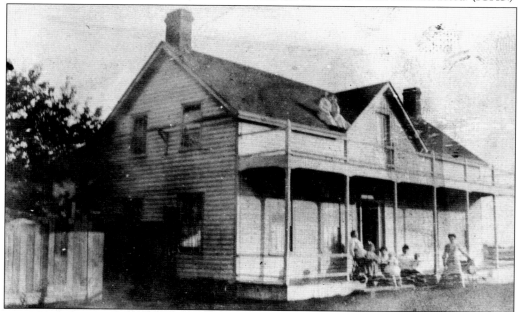

It is left to wonder how women wearing long skirts in the early 1900s climbed onto the Ferry House roof, but they undoubtedly had a spectacular view of Ebey's Prairie. Known as Ebey's Inn, it was built after Isaac Ebey's death as a source of income for sons Ellison and Easton. Boat and canoe passengers came to the inn, which served as tavern and hotel. The two parlors, one for gentlemen and one for ladies, provided socially acceptable settings. (NPS.)

Three

GROWING A TOWN

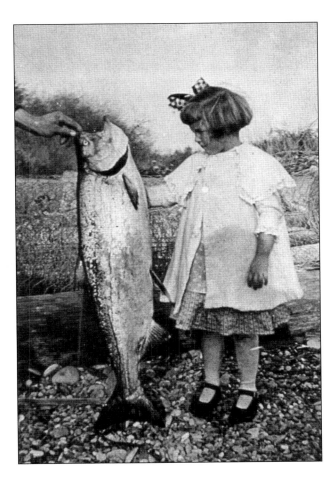

Whoever caught this fish in the late 1800s or early 1900s could boast to friends that his catch was as tall as toddler Dean Jackson Bratsberg of Greenbank. The fisherman was able to amply feed a good number of people with this huge salmon. (ELNHR.)

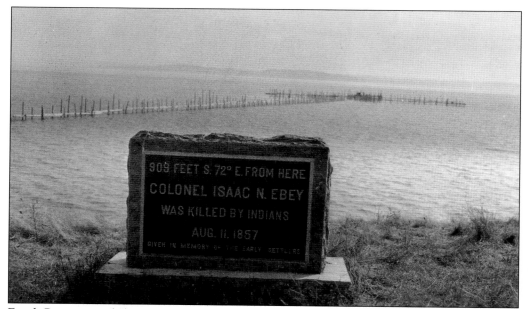

Frank Pratt erected this monument to Isaac Ebey near the site of his death. The fish trap in the background stretched a half mile from the beach. Pilings were driven into the seabed and connected by a latticework of netting, forming a funnel to capture fish 24 hours a day. Workers lived in a house at the water end of the pier. Fish trapping on Puget Sound lasted until 1934 when it became illegal. (LH.)

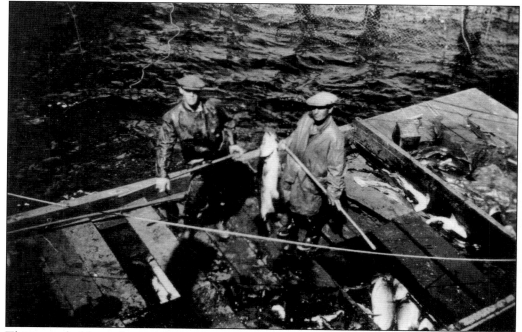

This scow holds workmen who came weekly to the Ebey's Landing fish trap to lift the fish from the trap's netting and remove them one by one so they could be transported to the canneries. (LA.)

The person at the top of this smelt lookout at Good Beach on Penn Cove just west of Coupeville could have been Aleck Kettle. The "lookout" alerted fishermen when he spotted smelt coming into the beach to spawn. (ICHS.)

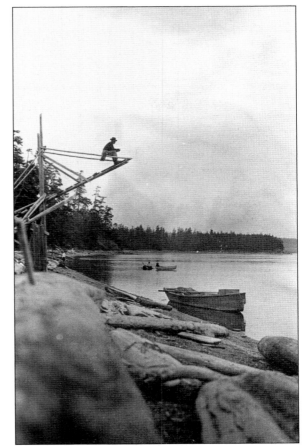

Smelt, tiny silver fish, were caught during their spawning by seining, as shown in this photograph, possibly of the Hancocks on a Penn Cove beach. Sport fishermen were allowed to use smelt rakes, wire baskets attached to the end of long poles, to lift the small fish to the beach. (ICHS.)

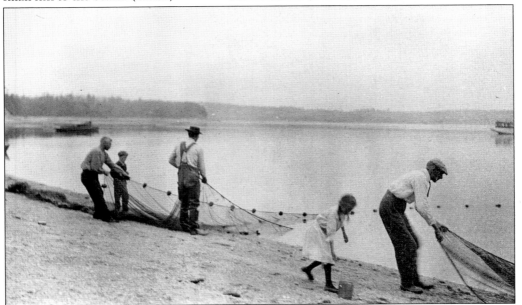

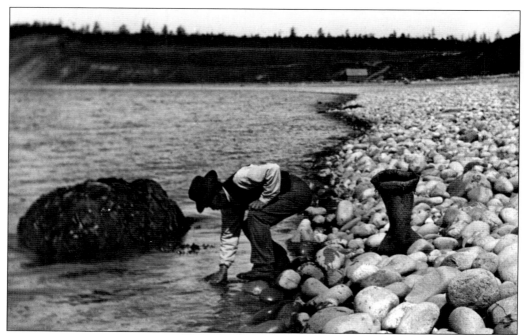

In this photograph, an unidentified Skagit man is collecting mussels, kelp, or other seaweed to be placed in his woven basket at Ebey's Landing. On the beach in the distance is a warehouse built by William B. Engle and later purchased by Ernest Hancock. It was presumably claimed by the tide. (UWLSC #23394.)

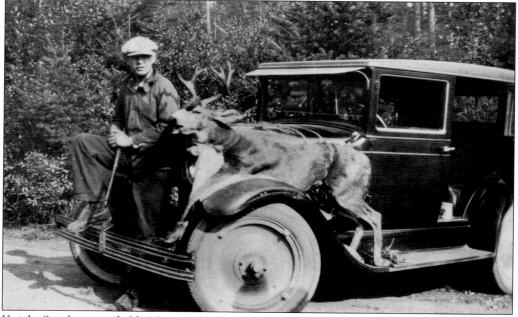

Knight Smith was probably 16 years old when he bagged this buck and posed with it on the fender of his 1928 Chevy. The head of the deer was stuffed and hangs in Toby's Tavern on Front Street, Coupeville. It is the one that sports a red bandana. (GS.)

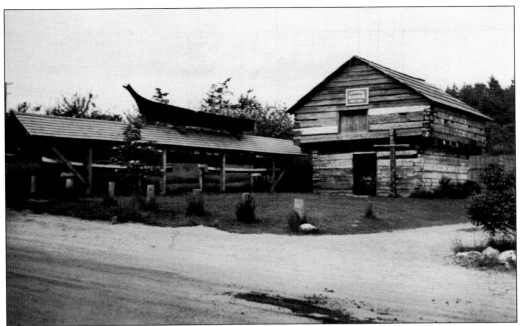

The canoe on top of the shed near the Alexander Blockhouse belonged to Chief Snakelum (an ancestor of Charlie Snakelum) in the 1850s. The three racing canoes below it were donated to the museum by George "Wiley" Hesselgrave. The Swinomish Tribal Community in La Conner donated the 50-foot-long *Telegraph* to Coupeville in honor of its hosting the yearly Water Festival. The shed now houses seven rare dugout canoes. The local Lions Club helped purchase, and volunteers maintain, the iconic canoe shed and blockhouse on museum grounds. (ICHS.)

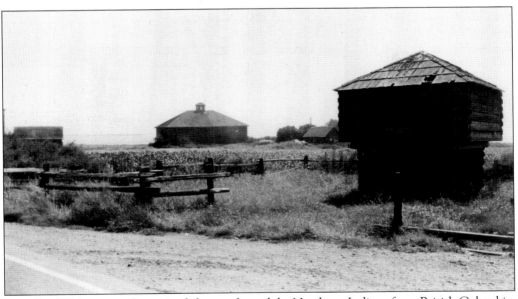

In early 1855, because of perceived threat of attack by Northern Indians from British Columbia, Ebey's Landing farmers built blockhouses in several locations in Central Whidbey. Visible in the background is the Crockett barn and Crockett Lake. (ELNHR.)

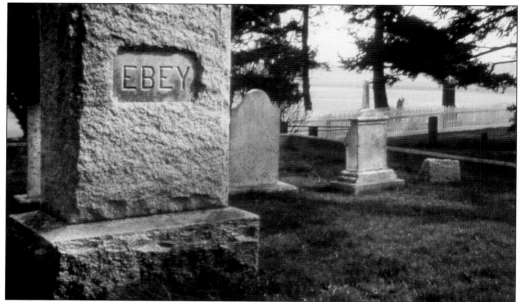

Sunnyside Cemetery, a pioneer burying ground named for Jacob and Sarah Ebey's Sunnyside Farm, overlooks Ebey's Prairie. According to historian Theresa Trebon, it began as the Ebey family's cemetery with the burial of Winfield Ebey in 1865. Island County purchased the burial ground in 1869. In the following decades, as farms sold and families moved elsewhere, numerous small farm burial grounds throughout Central Whidbey were exhumed and the graves moved to Sunnyside. (ELNHR.)

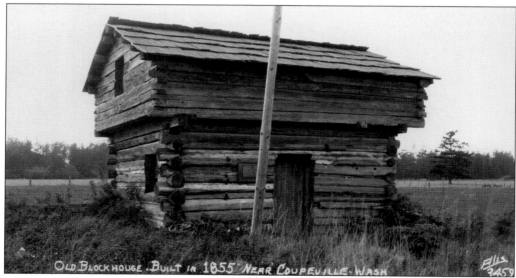

The Davis Blockhouse, a log structure with gable roof erected on the Davis land claim, is located in Sunnyside Cemetery. It was built in 1853 as a log cabin and converted into a blockhouse in 1857. In 1930, it was restored through the efforts of the Ladies of the Round Table. This is one of four blockhouses that remain in Central Whidbey; originally, there were eleven. Most were built during the Indian Wars of 1855. Although local Native Americans were peaceful, settlers feared northern tribes. (ICHS.)

Perhaps 400 to 600 years old, the size of Central Whidbey old-growth fir trees made for daunting work. These intrepid loggers in 1908 are using a crosscut saw and standing on springboards to elevate them and their tools above the undergrowth, put them level with each other, and help them avoid the base of the tree, which was full of pitch. (LS.)

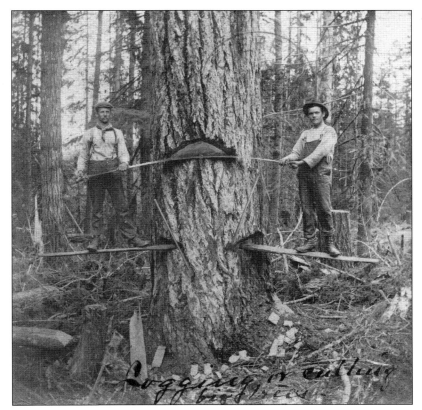

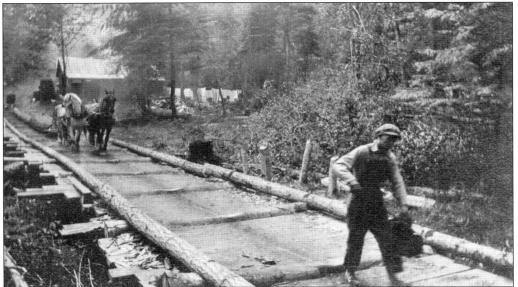

Skid roads were roads made of logs and used to skid or drag newly cut timber through the forest to sawmills, rivers, or roads. This photograph shows Shirley Parker in the early 20th century on one of Whidbey's skid roads. The logs constructing these roads were often coated with dogfish oil to make log movement easier. (Diane Eelkema.)

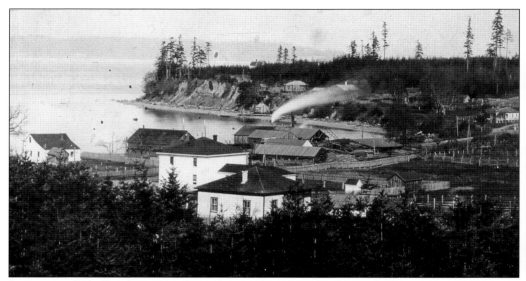

Logging on Whidbey began in the 1850s. By the 1860s, lumbering became an important part of island commerce, and by the 1890s, logging camps and lumber mills on Whidbey employed hundreds of men. In 1902, Coupeville's Island Manufacturing Company cut over 6,000 feet of lumber a day. The trail of smoke marks the Lovejoy Logging Mill on east Front Street. The bluff in the background is Lovejoy Point. (ELNHR.)

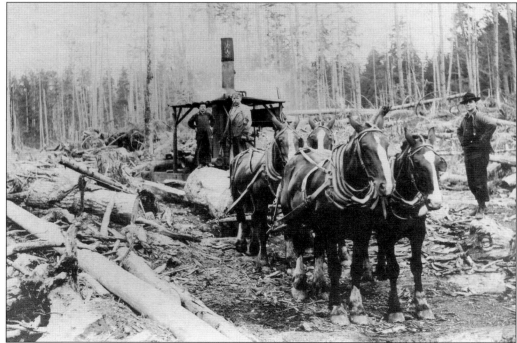

Moving logs using humans and animals was slow, backbreaking work. In the late 1800s, a primitive steam winch called a donkey engine (so named because the first model looked too small and puny to be measured in horsepower) was used to haul logs out of the forest. This donkey engine was used on Whidbey in the early 1900s. (LA.)

Four

BOOSTING A COMMUNITY

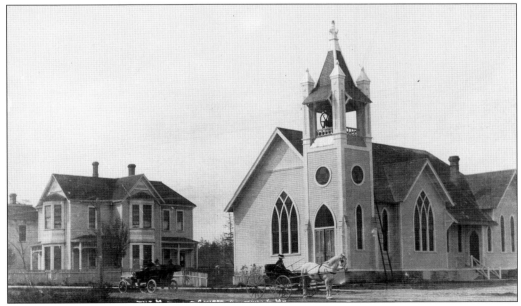

The Methodist Church has served Coupeville since early settlement. Originally, services were conducted in homes whenever a circuit-riding minister came by; the first service was held in the Isaac and Rebecca Ebey home on April 24, 1853. Rebecca Ebey wrote in her diary, "We had a tolerable good congregation and heard a good sermon." The Coupeville United Methodist Church is the third oldest Methodist congregation in Washington. (LH.)

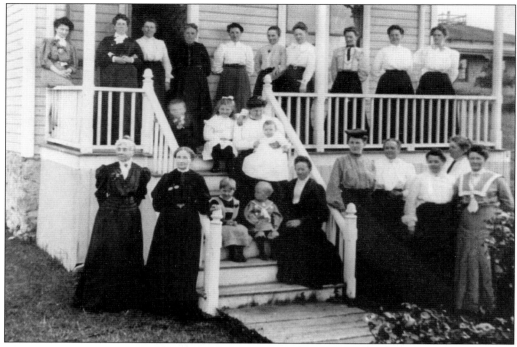

In 1889, Methodist Church trustees built a new parsonage, which was used for over 60 years. The residence still stands with extensive additions. Pictured in the early 1900s, the Ladies Aid Society of the church is presently known as the United Methodist Women. The group holds fundraisers to support nonprofits and those in need here and around the world. Pioneer Calista Lovejoy Leach is at lower left. (RS.)

Coupeville's second Methodist church was built in 1886 and located on Main Street. In 1893, it burned down; church insurance had expired 12 days earlier. The present church, built by Howard Bartlett Lovejoy, rose on the same site in 1894. In 1933, a foundation rock from the original church was placed in front of the current church. This photograph includes, from left to right, Mary LeSourd, Rev. Ray Partee, Julia Hancock, and Agnes Jenne. (RS.)

Coupeville's Congregational church was built in 1889 by Howard Bartlett Lovejoy, who also constructed the Methodist church. In 1934, the church was sold to the Catholic Diocese for $1,500. The Puget Sound Academy (right) and the dorm (left) were constructed in 1896 after the first academy burned and closed in 1908. The academy was built by the Congregational Church for advanced learning. (ICHS.)

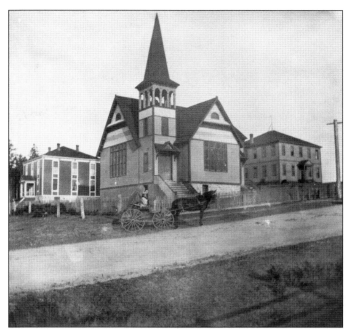

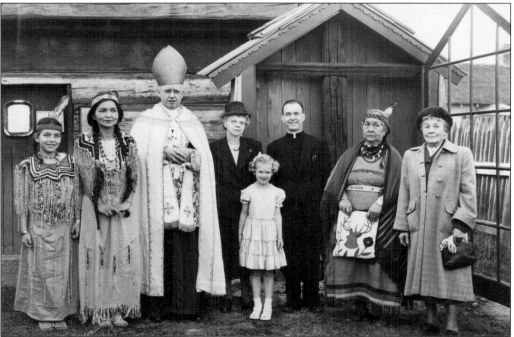

In 1939, Catholic officials rededicated the cross that had been presented by Whidbey tribes to Fr. Frances Blanchett in 1840. From left to right are June Millholland and Mrs. Ernest Millholland (descendents of Chief Sealth), Bishop Connolly, Ida Sill, Carolee Engstrom (great-granddaughter of W.B. and Flora Engle), Father Harrington (Catholic priest on Whidbey), Mrs. George Snakelum, and Teresa Kittle (grandniece of Francis Blanchet). The cross still stands in its case near the Alexander blockhouse. (ICHS.)

Members of the Pratt family deserve much credit for the preservation of significant areas of land and historic structures in Ebey's Prairie through their long ownership. Frank Pratt was an international law attorney in New York City when he purchased a summer home on Whidbey in the early 1900s with his first wife, Helen. His second wife, Lena Kohne Pratt (left), and son Robert (below) are pictured here. Lena Pratt, born on Whidbey Island, became a teacher and later Island County Schools superintendent. The family owned considerable property, including the Jacob Jenne Farm and part of the Ebey Donation Land Claims, including the Ferry House. Robert, an avid naturalist, was dedicated to preserving the land in its natural state, and after his death in 1999, his wishes were fulfilled through conservation easements, including those purchased by the Nature Conservancy. (Both, NPS.)

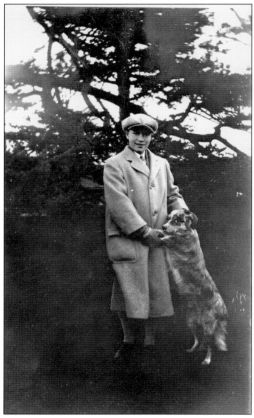

HB hmen

Capt. Joseph Warren Clapp, a sea captain and a local public official, built this home on east Front Street in 1886. It was to be the family home for 50 years, and it is still standing. Enjoying an outstanding view of Penn Cove are Selma Cranney, Sarah Coupe Cranney, Thomas Cranney, Leila ?, Captain Clapp, Mollie Cranney Clapp, Fred Cranney, Ida Cranney Newberry, and Linnie ?. (ICHS.)

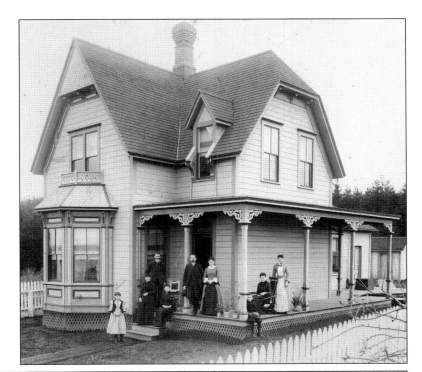

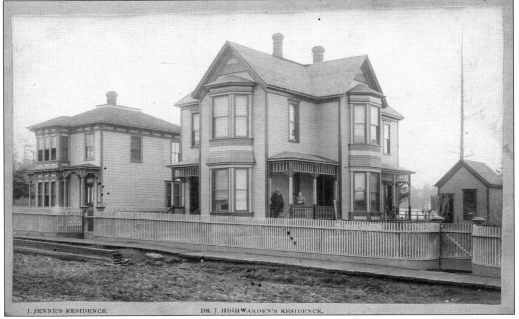

J. JENNE'S RESIDENCE. DR. J. HIGHWARDEN'S RESIDENCE.

Jacob "Jake" Jenne's house (left) on Main Street was built in 1889 by H.B. Lovejoy. The owners of the house to the right (built in 1888) were Dr. Joshua and Anne Crockett Highwarden. Advertising himself as the "Portuguese Physician and Surgeon," Dr. Highwarden lived extravagantly, but his estate did not cover his debt. An 1893 fire destroyed the church next door and the papers dealing with the estate. (ICHS.)

Calista Kinney Lovejoy Leach first came to the Coupeville area in 1854. While visiting the Coupes, she met Capt. Howard Bentley Lovejoy, and they married in 1855. Captain Lovejoy died in 1873, leaving Calista a widow with six children to raise. She supported her family by sewing and hired an Indian to transport her and her sewing machine to Oak Harbor by canoe. She married John Leach in 1881. Until she was 80, Calista frequently rode her bicycle along Main Street. (ICHS.)

H.B. Lovejoy, local craftsman and builder, constructed this house, currently known as the Zylstra house, as his residence in 1889. It was later sold to prosecuting attorney James Zylstra in 1917. Zylstra was active in county and state government and served as Coupeville's mayor from 1913 to 1918 and again from 1921 to 1927. The home was later owned by Jimmie Jean Cook, author of *A Particular Friend, Penn's Cove.* (ICHS.)

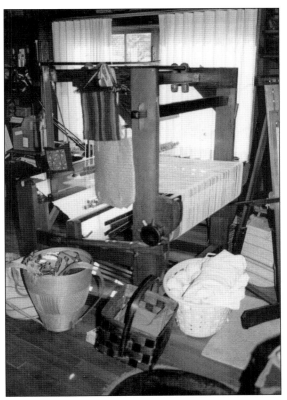

This loom in the Fullington bedroom was used to weave items for use and sale by Maude Swift Fullington's craft business, the Skagit Indian Tribal Trading Post. Neighbors Aleck and Susie Kettle were employed to spin yarn for her weaving and knitting; one of their knitting bags was sent to Eleanor Roosevelt in 1939. Both Maude and her daughter Mary (below) were weavers, and the loom and spinning wheel they used are in the museum archives, as is the thank-you letter from Mrs. Roosevelt and a canoe carved for young Mary by Aleck Kettle. Their house was built in 1859 on the north side of Penn Cove and was later disassembled and then reassembled just west of Town Park. It was moved a second time when Maude thought it was too close to the bank above Penn Cove. Natives Charlie Snakelum and Aleck Kettle split 400 cedar shakes for the interior walls. (Left, Judy Lynn; below, ICHS.)

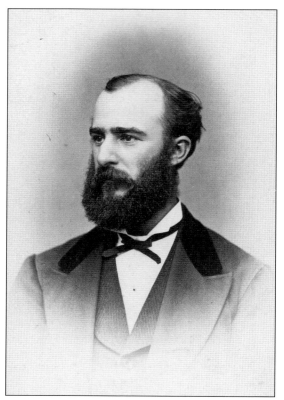

With his mother and brother, 10-year-old Joseph Barstow (J.B.) Libbey (left) followed his father, Samuel, from Maine to the Pacific coast in 1859. Family patriarch Samuel Libbey arrived on Whidbey in 1853, taking out a Donation Land Claim on West Beach. J.B. Libbey served as postmaster, county treasurer, county auditor, and reportedly in nearly every public office in Island County. In 1877, J.B. Libbey and his wife, Marietta Cook Libbey, purchased this house (below), which was built in 1871 by John Alexander Jr. Their children Clara, Howard, Jessie, and Leona were all born in the home, and four generations lived in the house until 2002. The inscription reads, "Housecleaning, painting, and papering, May 1904." From left to right are Charlie Davis (Clara's fiancé), Clara Libbey Willard, Leona Libbey Little, and Howard Libbey. (Both, LA.)

This is an early photograph of the "highway" near Coupeville. There were reportedly 22 square corners put in the road to slow traffic. Traveling by horse and carriage was time consuming and tiring. During the 1940s, road crews tried to straighten the road and bank the curves. Hobe Race, one of the workers, said, "Those corners were 'as crooked as a dog's hind leg.'" A road all the way to Langley was not completed until 1916. (ICHS.)

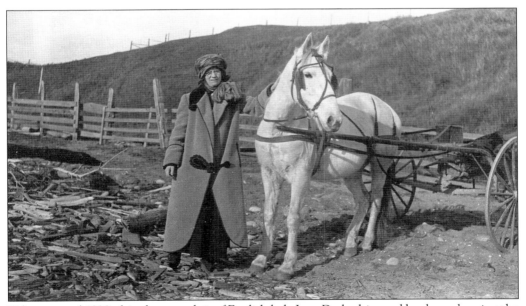

Taken around 1930, this photograph is of English lady Jean Derbyshire and her horse braving the wind at Ebey's Landing. (LH.)

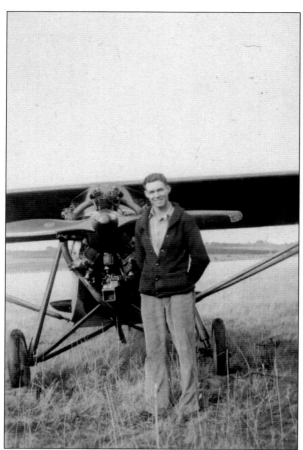

Daryl "Hike" Willard owned the first airplane on Whidbey Island. He appears with his Monoprep in November 1932. He and other pilots used farms on both Ebey's and Smith Prairies as landing strips, and one was later dubbed "Alfalfa International" when an official name was required by the Federal Aviation Administration. Hike died in his 50s doing what he loved—flying. This is a rare photograph of Hike; often, when someone pointed a camera at him, he "took a hike." (LA.)

In 1919, high winds forced this plane to land in a field on the Smiths' Ebey's Prairie farm. Among the curious onlookers are J.L. Hancock, Nellie Dock, Vera Hancock, and Carl Dean. D.P. Dean is at left holding grandson Phil. (LH.)

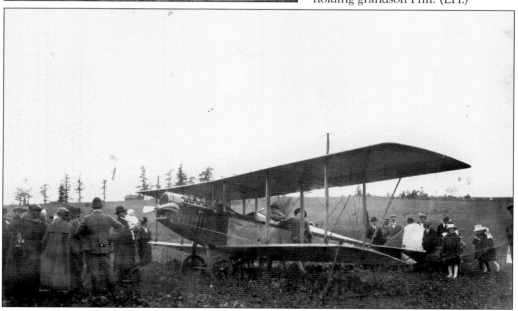

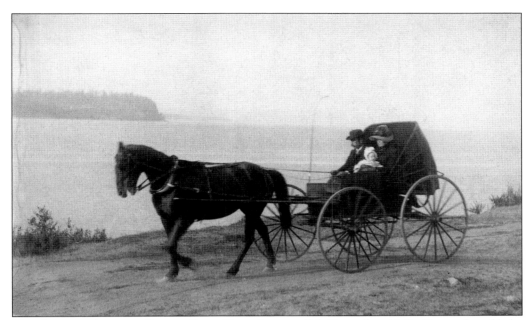

Traveling in style in east Coupeville on Penn Cove are E.J. (Ernest) and Julia Hancock and baby Ammon. The horse and buggy were wedding presents from Ernest to Julia. (LH.)

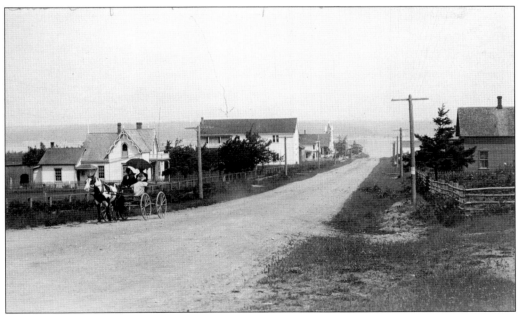

At center left is the International Order of Odd Fellows (IOOF) Hall. The hall was used for movies, graduations, and dances, and a roller-skating rink on the first floor was open to the public. Before the hall was razed in the early 1950s, the lower floor had been converted into apartments. In the buggy, Sadie Cook and her unidentified companions have passed the Libbey house on their way south on Main Street. (ICHS.)

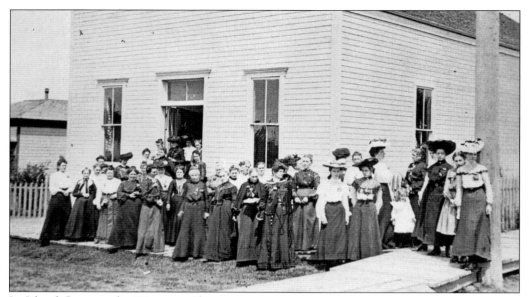

In Island County, the Woman's Christian Temperance Union (WCTU) was responsible for the demise of hard spirits long before the enactment of the 18th Amendment. This building at the northeast corner of Seventh and Main Streets was constructed in the 1890s and used as a community center and theater, especially by the Methodist congregation across the street, as many WCTU members were Methodists. It also served as the first theater in Coupeville. The building was demolished in 1937. (ELNHR.)

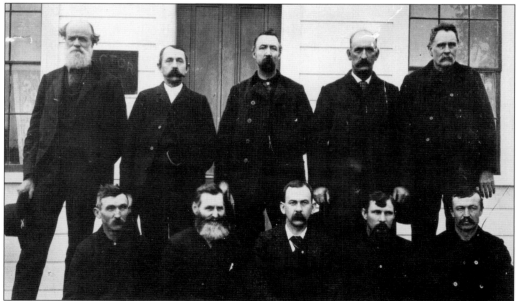

The Masons, Whidby Island No. 15 Lodge, was organized in 1869 with Granville O. Haller as its first worshipful master. After meeting in the Good Templars Hall (on Front Street), John Alexander built a Masonic hall in 1874 at the southwest corner of Main and Eighth Streets. From left to right are (first row) Jerome Ely, Thomas Cranney, A.D. Blowers, Isaac Sill, and Jacob Jenne; (second row) Emerson Mitchell, Capt. J.W. Clapp, Joseph Power, J.M. Babcock, and Walter Crockett. (LH.)

A CIGARET ARITHMETIC

"I am not much of a mathematician," said the Cigaret, "but I can and do

Add to a man's nervous troubles; I can

Subtract from his physical energy; I can

Multiply his aches and pains; I can

Divide his mental powers; I take

Interest from his work, and

Discount his chances for success."

National Woman's Christian Temperance Union, Fairs & Open-Air Meetings

43

Posters like this one sponsored by the WCTU in Coupeville in 1919 were reminders of the evils of smoking. (PD.)

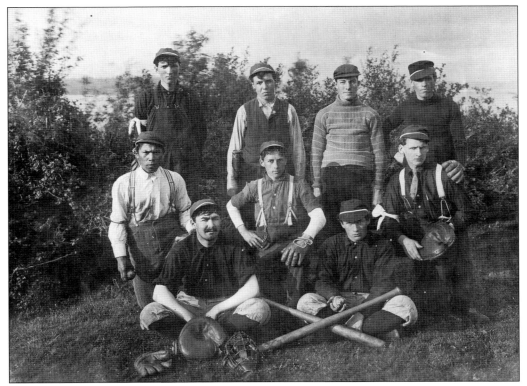

These members of a community baseball team look as though they have just lost a game. Identified players are Walter Jenne (third row, second from left), Charles Aleck (second row, left), and Arthur Jenne (first row, left). (ICHS.)

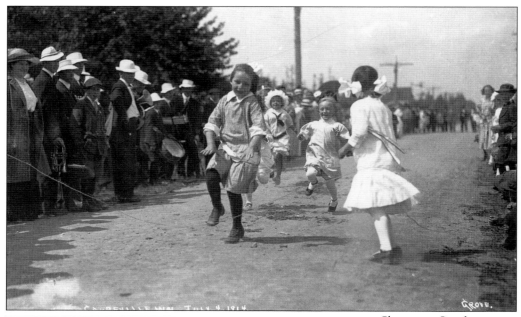

Shown on South Main near Prairie Center, these girls enthusiastically compete in a race to the finish line on July 4, 1914. (RS.)

Photographer Perry Grove captured Coupeville life in the early 1900s. Island County hired Perry to take photographs of jail inmates and built a darkroom for him in the old courthouse. Perry taught 12-year-old Herb Pickard to develop pictures. Pickard remembered, "The key was in a shrub; I could get in anytime I wanted. I'd visit with anybody who was in jail, and put the key back in the shrub." (MP.)

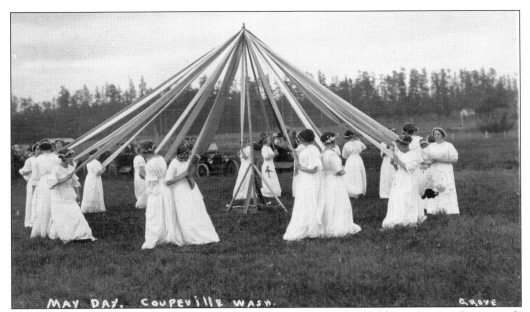

MAY DAY. COUPEVILLE WASH. GROVE

Photographer Perry Grove captured this 1915 May pole dance in a field near Prairie Center with the school in the background. Freshman through senior girls participated, and the tradition continued for many years. (Diane Eelkema.)

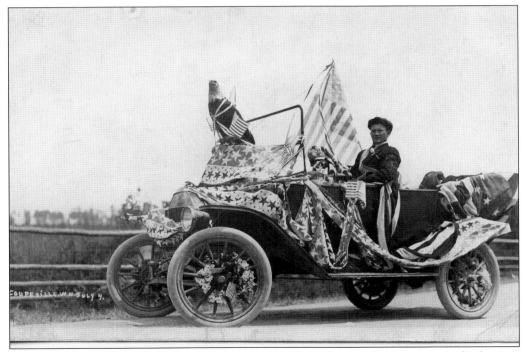

COUPEVILLE WN JULY 4.

This 1914 Independence Day photograph captures a fittingly magnificent patriotic display in a Coupeville parade. (RS.)

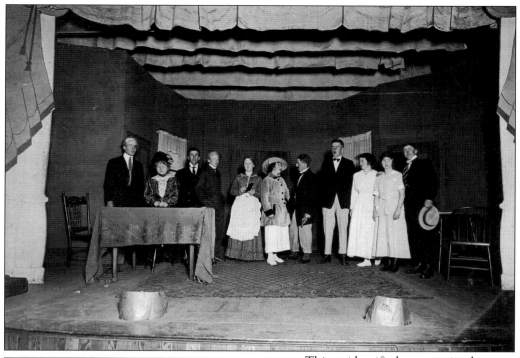

This unidentified community drama group (above) entertained audiences around the turn of the 19th century and into the 20th century, perhaps on a school stage, at the WCTU Hall, or at the IOOF Hall, as did the misspelled "Conpevllle Base Ball Vaudeville Co." in April 1911. (Above, ICHS; left, PD.)

VAUDEVILLE

The Conpevllle Base Ball Vaudeville Co.

—— WILL OPEN A ——

Second Series of Shows at

COUPEVILLE

APRIL 28, 1911

I. O. O. F. HALL

A High Class Entertainment
Consisting of Comedy Sketches
Solos, Duets, Recitations and
Many other High-Class Turns

TWO HOURS OF SOLID FUN
COME and ENJOY YOURSELVES

Admission 25 cents

Curtain at 8:30 Sharp

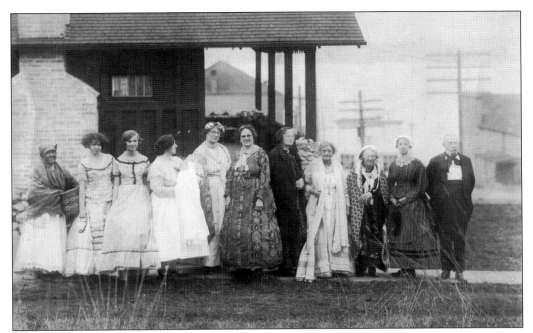

These women are likely members of the Daughters of the Pioneers in 1920. Betty Engle Engstrom (third from left) has black trim on her dress. Marge Engle is in the center in the print dress. The house was built by Judge Lester Still and still stands at Ninth and Main Streets on the foundation of the Puget Sound Academy, which burned in 1896. (ICHS.)

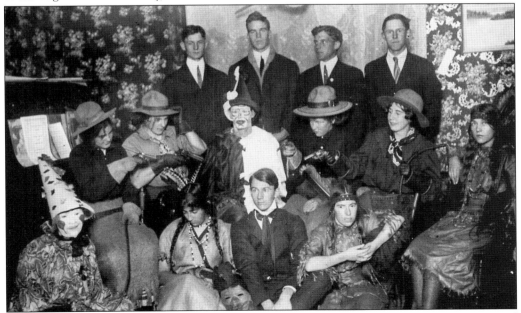

The Hancocks held a Halloween party featuring plenty of costumed guests around 1912. Pictured are, from left to right, (first row) Zilmah Vader, Edith Hancock, Kenneth Searles, and Lorena Coates; (second row) Marie Terry, Madeline Fisher, George Todd, June Sill, Doris Newcomb, and Fern Bearse; (third row) unidentified, Frank Morrill, Freeman Boyer Sr., and Ray Comstock. (PD.)

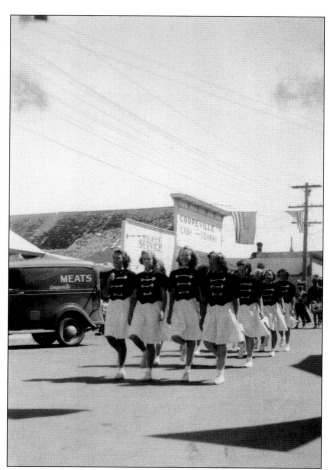

The Coupeville High School drill team is well represented in a parade down Front Street. Wiley's Service and Coupeville Cash and Carry are the present-day Toby's Tavern on the north side of the street. The 1935 panel truck advertises Coupeville Meats. (GS.)

Parades were the most favorite and best-known activity of the sheriff's posse. This parade is heading east down Front Street. The Coupeville Library building (left), also used for town hall meetings, was later razed. (ICHS.)

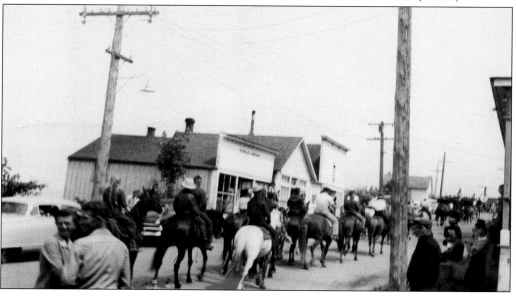

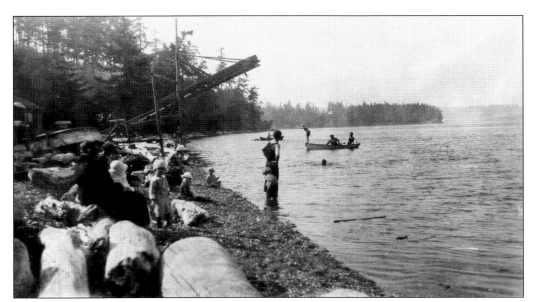

There were two smelt lookouts at Good Beach, just west of Coupeville. The beach was also a popular spot for swimming. Although some are braving the water, the day is not balmy, as evidenced by the families bundled in coats and hats. (LH.)

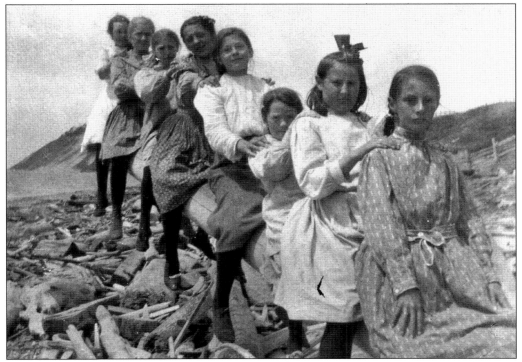

The Swastika Club was a young girls' social club. The name was selected before World War II because the members liked the ancient symbol. From left to right are Marie Terry, Beth LeGore, Gladys Kennedy, Helen Todd, Reba Kennedy, Mamie Black, Irene Smith, and Vera Hancock. This photograph was taken at Ebey's Landing around 1908. (LH.)

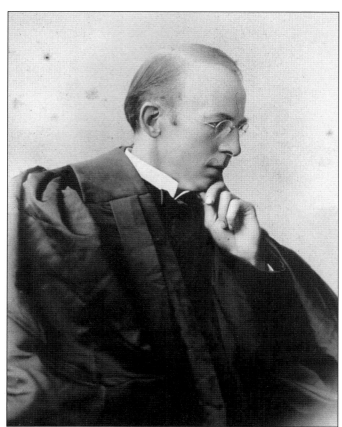

Lester Still served as prosecuting attorney for the county and was the first judge chosen from this area. He had built the Whid-Isle Inn at Coveland and a number of homes that still survive. He is credited with fighting to stop logging at Deception Pass, urging the state to preserve its old-growth forest as a state park, and calling for a bridge to be built there. (MC.)

In 1891, H.B. Lovejoy constructed the Island County Courthouse, which was used until 1949 when an Art Moderne–style courthouse was built. Jean Sherman recounted getting her driver's license at an office on the second floor. After passing a written test, she had to show the official she could drive: "He couldn't leave his office, but he told me he'd watch me drive from his window." (ICHS.)

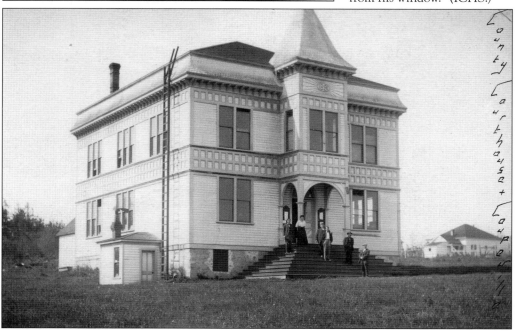

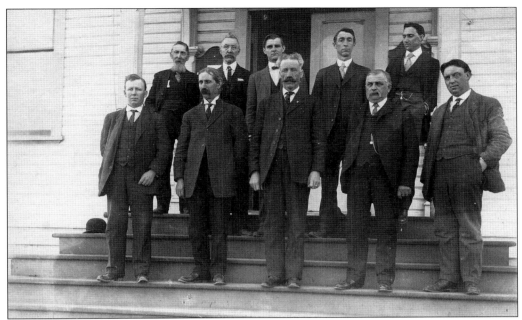

Island County officials have gathered on the courthouse steps in 1910. From left to right are (first row) Marcus Wangsness, G.F. Scholl, H.O.H. Becker, Riekele Zylstra, and Luther Weedin; (second row) W.H. Ives, J.C. Power, James Zylstra, J.W. Hannah, and W.J. Waldrip. (ICHS.)

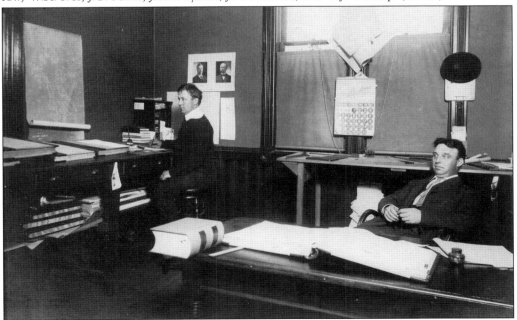

Shown in the assessor's office at the Island County Courthouse, county clerks Marcus Wangsness (left) and Luther Weedin do not look too busy. In Island County, three generations of Libbeys worked as auditors. Joseph Barstow (J.B.) Libbey was the first, followed by his son Howard W. Libbey. When Howard died, J.B. Libbey was appointed to complete his term. Howard's son Joseph "Joe" Libbey was later elected auditor and served 34 years. All three died while still in office. (ICHS.)

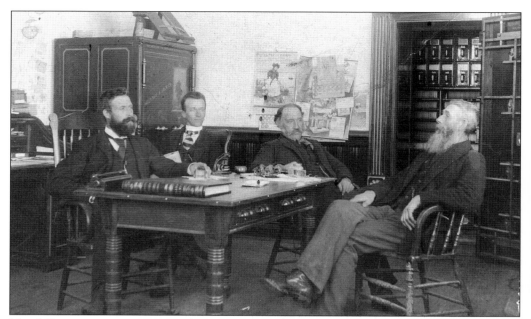

Island County commissioners are discussing county business in the courthouse in the early 1900s. James Zylstra is second from left. (ICHS.)

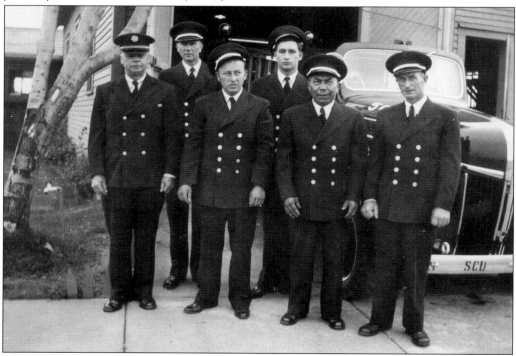

This small wooden garage was replaced with a two-story masonry building, constructed in 1937 to provide storage for Coupeville's firefighting equipment. The firefighters' quarters were on the second floor. Pictured from left to right are two unidentified, Robert Bruce, Art Youderian, Charlie Aleck, and Bill Snyder. (ICHS.)

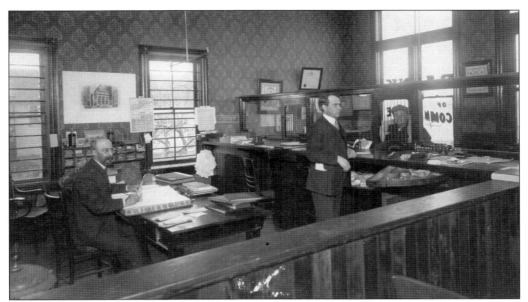

J.B. Libbey (left) is seated in the Bank of Commerce at Front and Center Streets in 1908. The manager prior to J.B. Libbey was an embezzler and was described as a "real charmer." Tried but not convicted, he skipped town without paying his lawyer. Chuck Ruthford was hired as manager in 1928. Carol Ruthford Thrailkill recalled, "The front part of the building was the bank; we lived in the back part. The door from my folks' bedroom led into the bank; Dad just opened the door and walked through." (LA.)

In 1890, a jail was constructed near the courthouse. The only remnant of the original courthouse (demolished in 1949) is the vault, which still stands at the site because it could not be destroyed by the munitions available at the time. Ron Van Dyk recalls, "My dad once took me to the jail and asked the sheriff, Tommy Clark, to lock me up as a joke. I didn't think it was funny." (ICHS.)

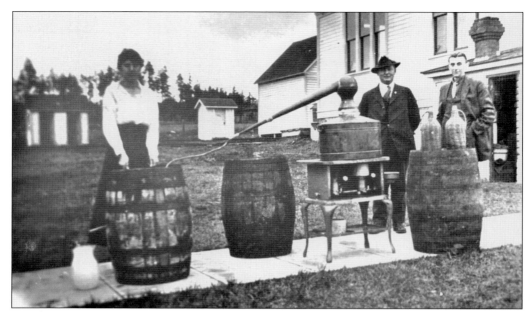

A confiscated moonshine still is displayed in front of the Island County Courthouse in 1919 by Ruth Terry Harrison (left), Sheriff F. Armstrong (center), and Howard Libbey. During Prohibition, local stills helped meet the demand for liquor. A 1926 newspaper stated that Sheriff Gookins was "indicted as one of the 'higher-ups' in an alleged rum-running conspiracy." He was not convicted and returned to his position as sheriff of Island County. (Toby's Tavern.)

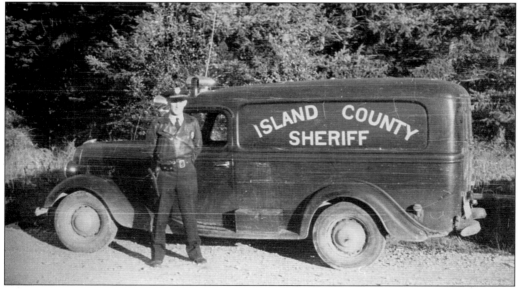

Coupeville's town sheriff Tommy Clark is shown next to Island County's 1935 paddy wagon. At 39 years old, he was the youngest sheriff elected in Washington state. His grandfather Tom Clark Sr. came to Whidbey as a member of the military at Fort Casey and later retired. Tommy's brother Mickey Clark became a well-known local historian. When Tommy was not chasing criminals, he played the drums in a band that performed at the IOOF Hall, and he loved playing baseball on the town team. (ELNHR.)

Dr. John Kellogg and his wife, Caroline, arrived in the spring of 1854. On their Admiralty Head land claim they built a hospital for sick and convalescing patients. Dr. Kellogg was known as the "canoe doctor" because he relied on a cedar log canoe paddled by Native Americans to reach patients throughout Puget Sound from Port Townsend to Whatcom. (ICHS.)

Dr. George V. Calhoun lived in this home next to the "Rock of Ages," or "Big Rock," near Prairie Center from about 1901 until his death in 1916. He was one of the most pivotal physicians in the history of Washington state and was instrumental in the passage of the first laws protecting public health. The Parish Home Hospital was operated by Maria Arnew Parish Grant, RN, in this home in 1936. The rock, which dwarfs the former hospital, is greenstone that came from Mount Erie on Fidalgo Island and is among the largest glacial errata in Washington, making it a draw for people interested in geology and offbeat tourist attractions. (LH.)

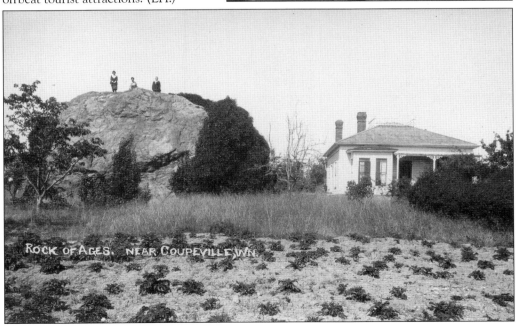

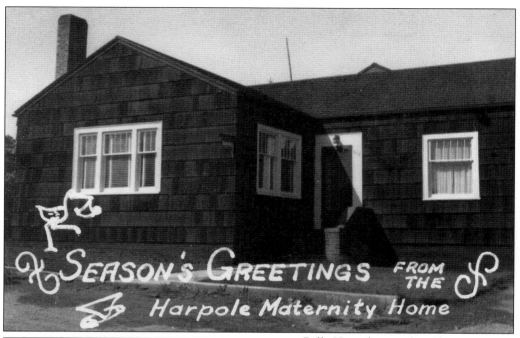

Polly Harpole sent this Christmas card photograph of her Harpole Maternity Home to her "families." The building on Haller Street is now privately owned. (JS.)

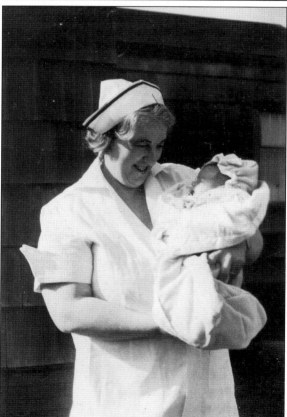

There were nearly 3,000 babies birthed at Polly Harpole's Maternity Home between 1936 and 1962. Harpole, a nurse and University of Washington graduate, was Coupeville's first public health nurse. She set up child health clinics, dental clinics, speech workshops, mobile X-ray visits, and well-baby clinics. Countless Coupeville residents refer to themselves as "Harpole babies." Polly holds Sara Jean Sherman, daughter of Wilbur and Grace Sherman, on February 6, 1944. (ICHS.)

Dr. Paul Bishop moved to Coupeville in 1949. He was busy and respected and was often paid in trade. According to son Malcom, "People brought fish and a lot of stuff in payment." Dr. Bishop had a reputation for driving his 1949 Packard at high speeds. Malcom remembers, "When he went to the Sheriff's office once the Sheriff said, 'Doc, I tried catching you last night, but I couldn't keep up with you.' " (MB.)

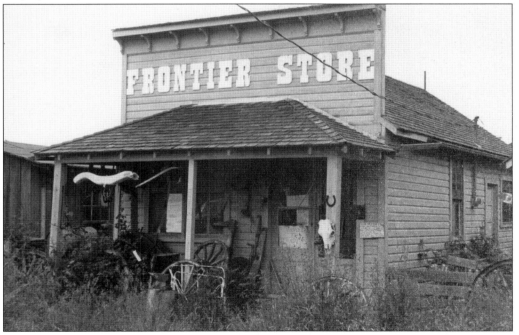

Dr. T.H. White's dental office started on east Front Street. When White married Bertha Kaehler Jenne, he had this building moved behind her house on Main Street where he continued to practice dentistry. Dr. White pedaled to power his drill. According to Leone Willard Argent, "He couldn't pedal very fast, so the drilling was more like grinding and very painful." Later, Betty and Jack McPhee sold antiques in the building, renamed the Frontier Store. (ICHS.)

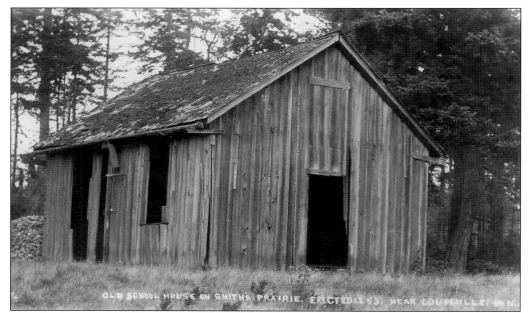

Mary Bartlett Power taught in this Smith Prairie school, one of the first schoolhouses on the island, in 1864 and 1865. For many years, schools remained in session for only 12 to 14 weeks a year because children were needed on the farms. Because the school season was short, teachers had additional occupations. Other nearby schools were on Ebey's Prairie and at Coveland. (RS.)

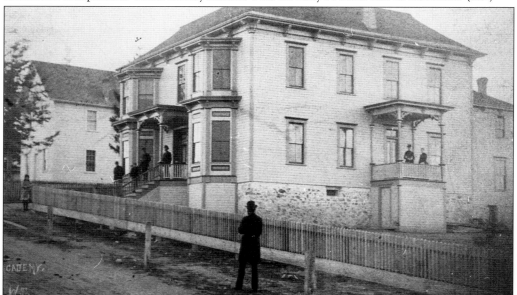

The Puget Sound Academy opened in 1887, and provided students of Puget Sound their first opportunity for a high school education. Classes were offered in natural science, math, philosophy, languages, history, music, art, and "ladies' deportment." In 1896, this original academy on the southwest corner of north Main Street burned, and a new building was constructed on land south of the Congregational church, presently the Catholic church. The building on the left is the Masonic Hall. (ELNHR.)

"Studious" chickens wait their turn to ride to school on a school bus that dates to around 1913. (ICHS.)

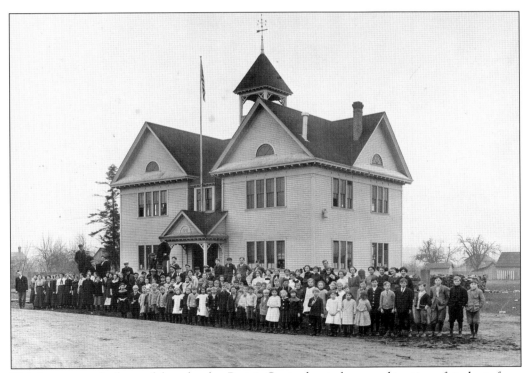

This large group in front of the school at Prairie Center has to be a combination of students from both the elementary and high schools in the early 1900s. (ICHS.)

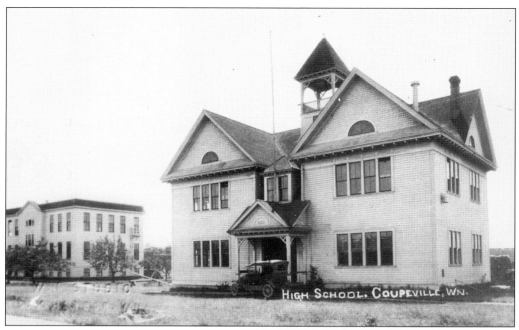

HIGH SCHOOL. COUPEVILLE, WN.

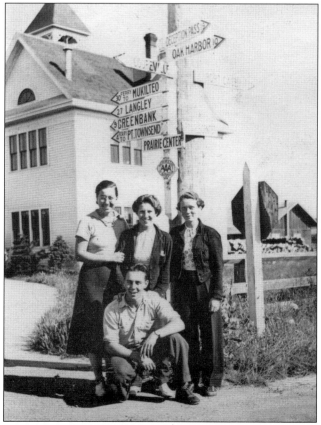

The two-story wood-frame school on the left in this photograph was constructed in 1913 as the first separate high school. The building on the right with the belfry (which is misidentified as the high school) was built for all grades in 1901 near the Main Street and Terry Road crossing in Prairie Center. In September 1913, classes began in both school buildings. (FB.)

This 1935 photograph is of friends (from left to right) Drucilla "Drucie" Dean Lynch, Jean Higgins Sherman, Isabelle Fisher Berry, and Herb Pickard at Prairie Center corner. Jean and Isabelle, known as the "Gold Dust Twins" because of their red hair, were involved in cheerleading, tennis, and basketball. Jean recalls, "Since there were so few kids in our class, and we were on the basketball team and were cheerleaders, we'd have to call time-out to lead a cheer and then start the game again." (MP.)

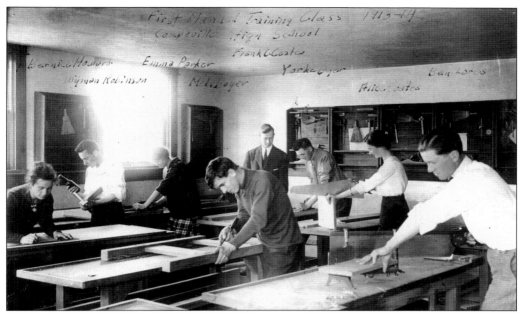

In this picture of a 1913 high school coed woodshop class are, from left to right, Bernice Howard, Syman Robinson, Emma Parker, Melvin "Mel" Boyer, Frank Coates, Yorke Dyer, Alice Coates, and Ben Lores. (ICHS.)

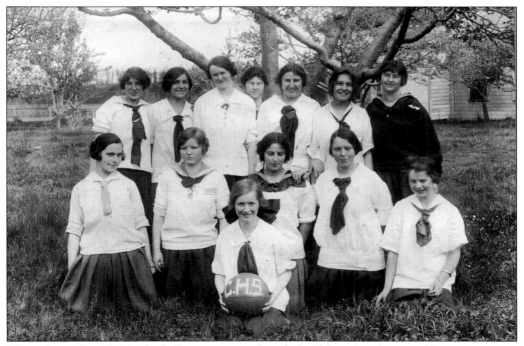

The girls on this 1917 basketball team are unidentified. Although girls were able to participate in sports, they had to play in skirts and were allowed to play only half-court. The girl in the first row at left is Bernice Howard Miller. (ICHS.)

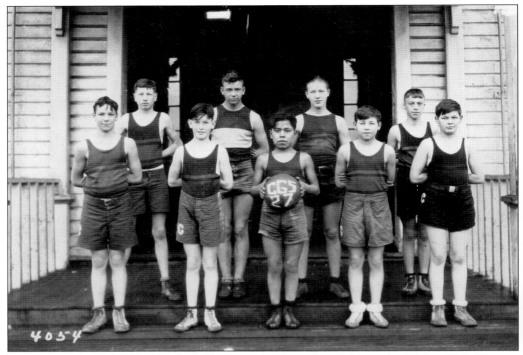

Members of the high school basketball team in 1927 are, from left to right, Walter "Babe" Jenne, "Brick" Webster, Don Jackson, T.J. Whelan, Eddie Kettle, Howard Davies, Ralph Smith, Victor Nichols, and Knight Smith. (ICHS.)

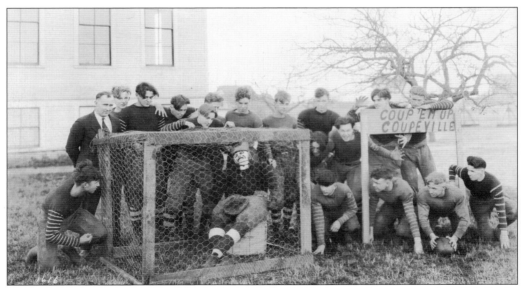

"Coup 'em up" is the intention of the football squad of 1925. Among those pictured are Bob Engle, Wesley Dickinson, Melvin Arnold, Roy Armstrong, Aaron Grove, Buster Sill, Melvin Grasser, Bob Cushen, Dean Edmundson, Fred Lovejoy, Howard "Skinny" Jenne, Joe Bruzas, Stanley Bruzas, Sam Kieth, Lewis Berry, and LaVerne Arnold. (ICHS.)

Five

FRUITS OF THEIR LABOR

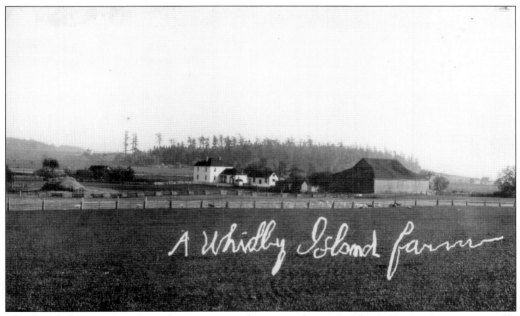

A Whidby Island farm

The Smith farm with its huge barn commands a central spot on Ebey's Prairie. It was originally called Willowood Farm when the land was owned by the Ebeys because of the willow trees that grew there. John Gould purchased the western half of the Ebey claim for $12,000 in gold coin in 1866. Ed Jenne leased the farm from 1893 until about 1902. Harry Smith and his wife, Georgia, bought the farm in 1919 using Georgia's inheritance for the purchase. The Smiths had been longtime tenants on the land. The house was built in 1896 and the barn a few years later. Georgie Smith, namesake and great-granddaughter of Harry and Georgia and daughter of Bill and Renee, continues the Willowood Farm tradition today. (RS.)

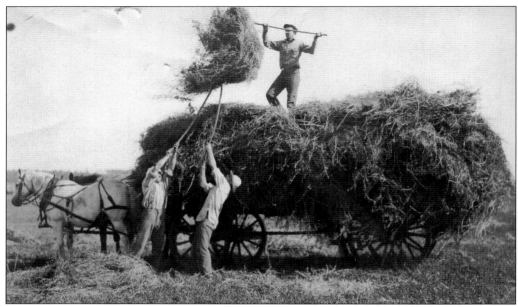

Before the baling of hay became common, a dump rake was used to bunch windrows into piles. These were stacked and allowed to dry. After drying, the hay was pitched onto a wagon, usually taking three men for the job. In this photograph, farmer Burton Engle is on top of the hay spreading the load evenly. (Burton is also pictured as a child on the front cover.) In northwest Washington, nearly all hay was stored in barns. (DE.)

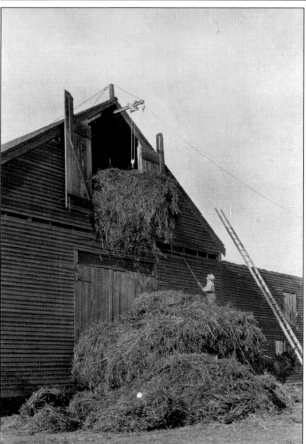

The Coupeville area has many barns. Iron tracks sticking out from the top of nearly all barns were used to lift piles of hay. Horses, and later tractors, did the pulling and lifting from the other side of the barn. Men, and sometimes women, spread out the hay inside the barn. This operation was not without hazards, such as lift ropes breaking or the lift person not hearing a shouted stop order. (DE.)

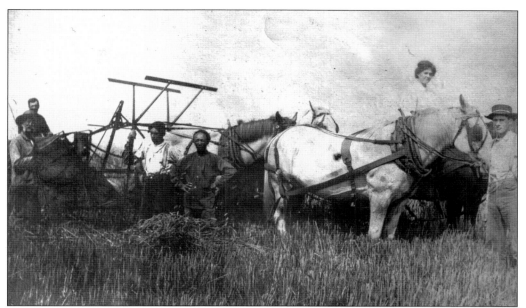

Throughout local history, various types of grain have been king of Central Whidbey crops. Wheat and barley were popular, but tons of oats were harvested during the draft-horse era. A binder cut and bundled the grain, and the bundles were stacked into shocks to dry. Bringing in the grain are, from left to right, C.H. Stackpole (with hat), Samuel E. Hancock, Virgil Hancock, Johnny Gong, Ruby Priest Hancock, and Justus "Jut" Hancock. (LH.)

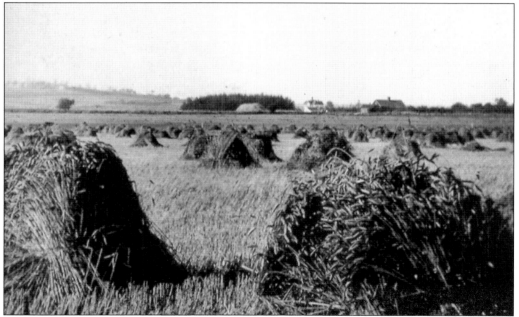

The grain in this field is in shocks. After drying, they are ready to be hauled to a thrashing machine. The photograph is of the Ebey's Prairie LeSourd Farm, some of the best farmland on Whidbey. During 1922, John LeSourd and Jut Hancock grew wheat crops that set a national record; 83 bushels per acre was a lot of wheat for that time. Both received cash prizes. (RS.)

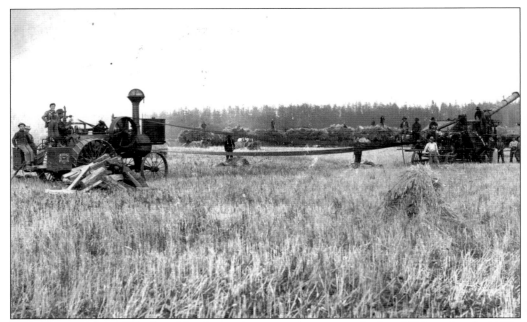

Grain harvesting on Whidbey Island was a major yearly event in the late 1800s and early 1900s. Starting in the late 1800s, thrashing machines were brought to the island. Although the task was still labor intensive, thrashing machines did an excellent job of separating the grain from the straw. The grain was put into 150-pound burlap bags that were sewn tight for shipping. During harvest season, the harvesters went from farm to farm; all farmers who had grain to thresh were expected to help harvest everyone else's. It was also expected that each farmer's wife would prepare the noon meal for a dozen or more in the hungry crew. Thrashing machines disappeared during the 1940s when combines were introduced. Harry Smith (below) owned and farmed about 300 acres on Ebey's Prairie near Coupeville. He is sitting on a pile of grain that is ready to be hauled to his granary. (Above, LA; below, GS.)

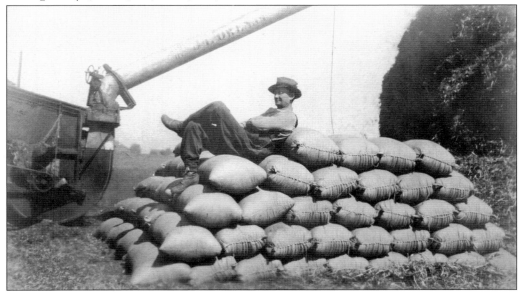

Leone "Sis" Willard handles the plow while her father, Dick Willard, drives saddle horse Babe on their farm south of Coupeville. Leone reported that they did not know if Babe knew how to plow, but after Dick stopped for a break and shared his chew of tobacco with the mare, "she got excited and there was no guidance necessary." (LA.)

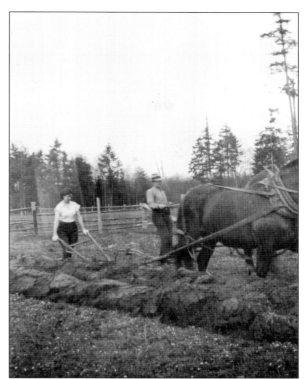

This is the first combine on Whidbey Island, purchased in 1937 by farmers Charles "Chuck" Arnold on the left and Robert "Bob" Hancock on the right. Arnold remembered, "Everybody told us we were crazy—that they wouldn't work in this country. So in '37 we drove around and did a lot of combining around the area in competition with the thrashing machines. That pretty much took out the thrashing machines." (EH.)

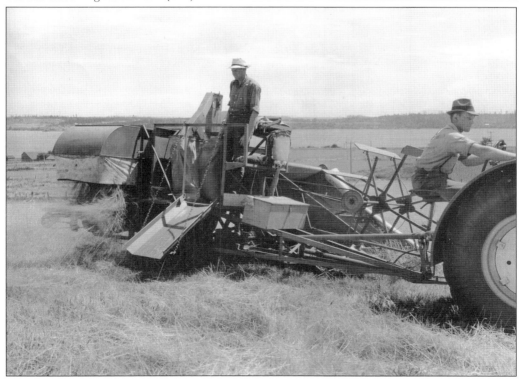

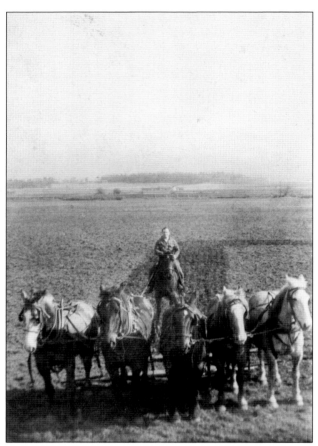

Farmer Knight Smith drives his team of five horses while on horseback, a most unusual feat. The team's task was to cultivate the Smith Farm in the center of Ebey's Prairie in preparation for planting. Although a tractor was available, Smith most likely used the horses for the fun of it. (GS.)

Squash has been an Ebey's Prairie crop since the early 1900s. Central Whidbey's Hubbard squash could be harvested in October, bedded in straw, and still be good in February. This truck is being loaded by, from left to right, Howard Davies, Robert Hancock, Charles Franzen, Virgil Buckner, William Powell, and Wilbur Sherman in October 1938. Sherman remembered a load he took to Portland; he drove all night, came home, had breakfast, and reloaded for Seattle. (EH.)

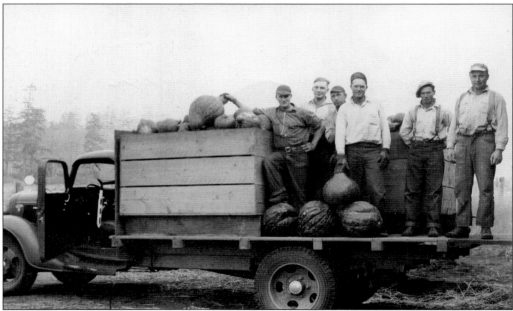

William "Billie" Sherman was the only gooseberry farmer on Whidbey. He started planting gooseberries during the 1920s. To harvest, berries were stripped from the thorny branches, moved through a blower to remove trash, and sorted by hand, as shown in this 1940 photograph. Sherman left the business in the 1940s when his sole buyer was a winery. A religious man, he refused to sell to anyone who made the "devil's drink." (RS.)

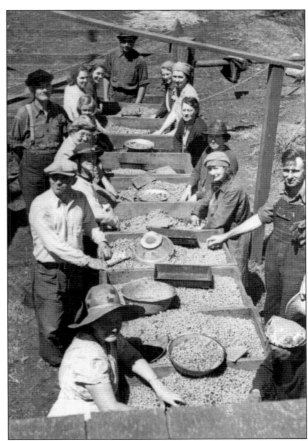

Starting in the mid-1930s, farmers discovered they could do better raising turkeys than chickens. Turkey farming did well until the 1960s when meat prices started to fall. Most farmers quit producing them, but Sherman Farms on Ebey's Prairie raised increasing numbers of turkeys to compensate for the low prices, eventually producing 100,000 a year. This photograph shows a large flock around 1940. (RS.)

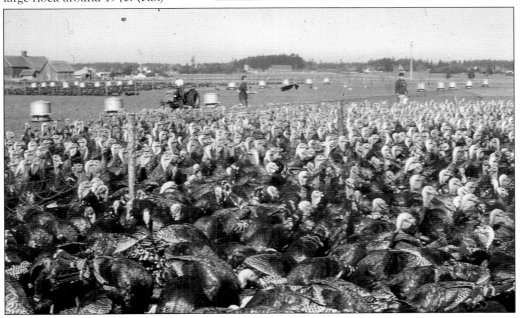

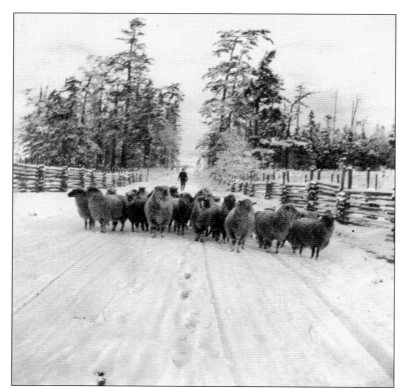

Justus "Jut" Hancock drives a flock of sheep down a snowy Whidbey road in 1916. Perhaps they are waiting for him to catch up and hoping to find ground that does not freeze their hooves. (Marilyn Bailey.)

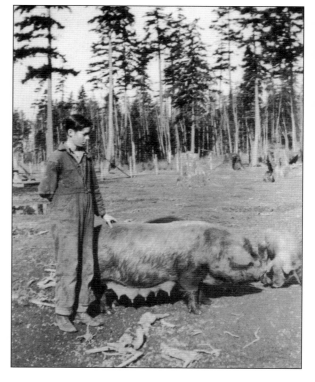

Pioneer John Alexander reportedly brought the very first barge-load of domestic animals to Whidbey Island in 1852. By 1860, nearly all farms around Penn Cove had livestock. Hike Willard tends to his sow Edith and her piglets in 1925. The children of all farm families had chores, which usually included taking care of animals. (LA.)

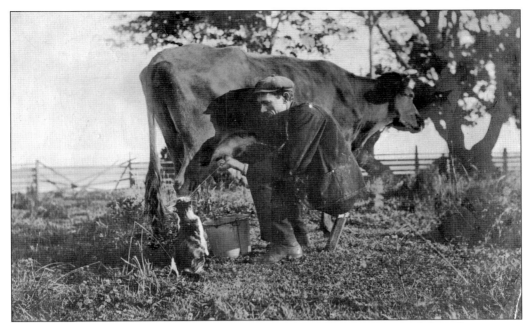

In 1896, Oliver S. van Olinda pleases a cat by squirting milk in its mouth while milking a cow. Olinda was a photographer, career newspaperman, and the editor of the *Island County Times* from 1900 to 1909. He purchased the newspaper in 1905 from Carl Pearson, nephew of Flora Engle. He also ran a printing shop and wireless office in Coupeville. (UWLSC #19105.)

Lawrence Reuble lived his life on the family farm south of Coupeville. After his father died, 15-year-old Lawrence took over the farm, milking 60 cows daily. He loved horses, and they were an invaluable help on the farm. He and wife Louise raised and trained Shires and showed them in fairs and parades for many years. This photograph shows Lawrence with son Lawrence "Pard" on Annie, their imported English mare. (Louise Reuble.)

Wash day at Aloha Farm was a family affair in 1895. Standing from left to right are James, Ammon, and Ernest Hancock, Hattie James (a hired girl), Miss Whelan, and Julia Hancock. Sitting at left is Claudine Hancock, James's daughter. Peeking out between Ammon and Ernest is a young Justus Hancock. The hand-operated rocker washer was given to the Island County Historical Society by the family. (LH.)

Freeman Boyer Sr. and daughter Alice Boyer are amused by the jumping abilities of their pet dog in 1921. Boyer and his wife, Doris, lived in the building behind them. (FB.)

Life was not all work for farm families. Hancock children Jut, Virgil, and Vera perform some acrobatics on the Aloha Farm in front of the woodshed. Jut and Vera often rode their bicycle to school with Vera standing on the seat. Lillian Huffstetler recalls the story of Vera falling off in the mud and changing clothes at a cousin's house before continuing on to school. (LH.)

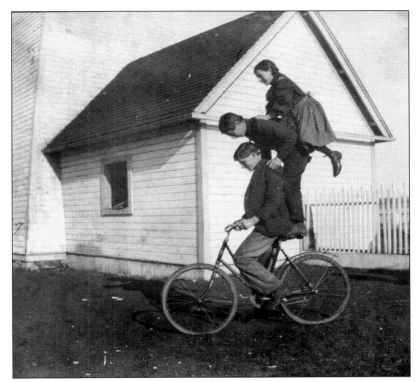

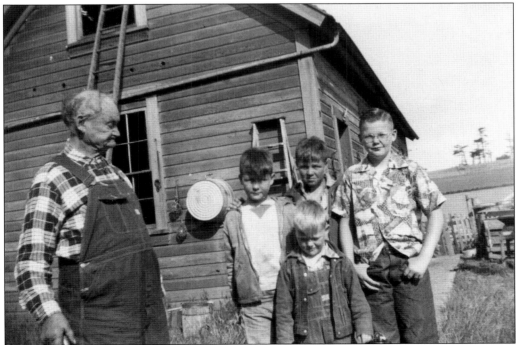

These young whippersnappers with Grandpa Harry Smith in 1952 are grandsons Steve (left) and Bill Smith (right) with Leroy Christenson in back and Jim Henry, a fourth grandson, in front. (GS.)

Shown in the front yard in 1899 are Ernest J. Hancock and his wife, Julia Kinney Hancock; daughter Vera holds her wheelbarrow. At center is Miss Whelan, a teacher at Puget Sound Academy in Coupeville. After Ernest and Julia moved into a home in Prairie Center, Vera and Carl Dean lived at Aloha Farm with children Philip, Drusilla "Drusie," Lillian, and Orlan from 1920 until 1929. The home was demolished by Julia in 1943. All the children were born in the house between 1918 and 1924. (LH.)

Julia Hancock is sporting her Sunday-best hat in 1910. The back of this postcard reads: "My dear Vera [Hancock]: if you are not scared of this picture you can come to Everett Saturday. I will meet you and get you shoes and a school dress." As a young woman, Julia taught school and became the first female Island County Schools superintendent. By Indian canoe and horseback, Julia visited all six schools in the county. (LH.)

Justus Lee Hancock, son of Ebey's Prairie farmers Ernest J. and Julia Hancock, and Frances Ruby Priest pose for their June 3, 1908, wedding photograph. (EH.)

This photograph is entitled "Not Enough Time." Appropriately, Vera Hancock and her father Ernest are sharing some reading time in the Aloha Farmhouse's parlor. Every room in the home had a double fireplace—eight total. The reason for Aloha Farm's name has been lost. (LH.)

Sabina Straub Kineth (above) sits in the doorway of a one-room building on Smith Prairie. Her husband, John H. Kineth, was a son of pioneers John and Jane Kineth, who took out one of the early Donation Land Claims on Penn Cove. The farmhouse (below), which still stands, was built by Sabina's husband for his parents. The elder Kineths first lived in a tent on their homestead near Snakelum Point, then in a log cabin, and in the early 1860s after the cabin burned, they built a frame house. They moved to this house on Smith Prairie in 1897 because the land was better for farming. (Above, UWLSC #19489; below, ICHS.)

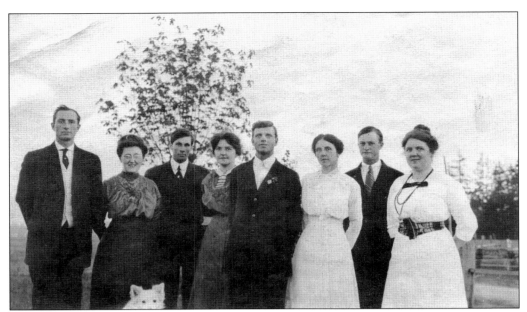

Pictured in 1920, Central Whidbey farmers Ralph and Beulah Engle, Jut and Ruby Hancock, Ben and Edie (Terry) Tufts, and Art and Ethel Kineth met regularly to play cards and board games. Edie and Ethel were sisters. The couples remained good friends all their lives. (DE.)

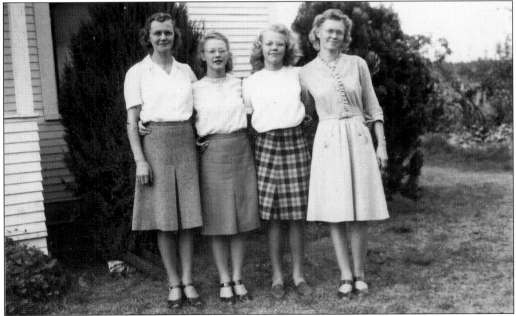

Barbara and Peter Sloth, Danish immigrants who settled in San de Fuca on the north side off Penn Cove, had four daughters. The sisters all married Central Whidbey farmers from pioneer families around the time of this 1947 photograph. From left to right are Viola, who married Charles Arnold; Opal, who married Freeman Boyer; Phyllis, who married Al Sherman; and Agnes, who married Bob Hancock. They contributed a great deal to the Coupeville community through their work, families, and social and religious activities. (PS.)

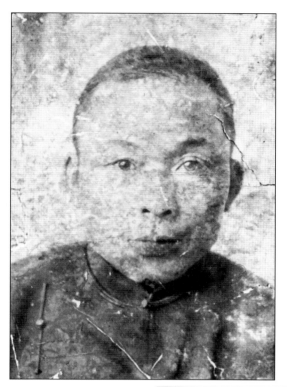

During the late 1900s, about 100 Chinese laborers settled around Coupeville. Pictured is Ah Soot, called the "LeSourd Chinaman" after the family who employed him until he died in 1925. He lived on the LeSourd Farm, was cared for by his employer, and wished to be "buried near his friend John LeSourd," and so was interred in the family plot in Sunnyside Cemetery, the only marked Chinese grave there. (RS.)

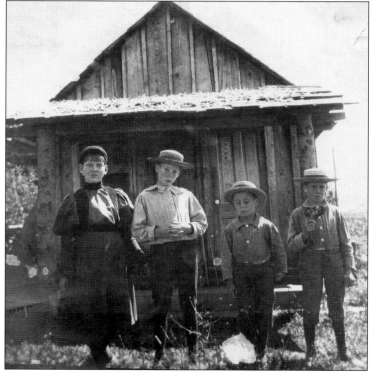

From left to right, Hancock children Claudine (cousin), Ammon, Virgil, and Justus stand in front of Lee Yu's (Leo) cabin with fish drying on the roof in 1896. Living without wives or families on prairie farms, Chinese men sent money home hoping to return to China to live in comfort. They often brought candy from Seattle to prairie youngsters. By 1910, there were only 28 Chinese in the county. By 1920, there were only eight. Lee Yu sold this cabin to Johnny Gong. (LH.)

Agreement Not to Rent Land to Chinese Tenants.

WE THE UNDERSIGNED, for and in consideration of the pecuniary benefits to ourselves and the welfare of the community at large, each with all the other parties hereto agree by these presents as follows:

1st.—Not to rent land either directly, or by permitting our tenants to sub-let, any land in our possession or under our control to Chinamen for the period of 2 years from date of this instrument; or to employ Chinese labor for farm purposes

PROVIDED, that this agreement shall not be binding unless all of the large land owners comply with this agreement.

This notice in the October 12, 1900, edition of the *Island County Times* expresses the hostile climate toward the Chinese on Whidbey Island. According to historian Jimmy Jean Cook, "They were in the community but never of it." The Chinese were discriminated against by whites, especially merchants who claimed "Chinamen" refused to spend money locally. They instead chose to shop in Seattle where there was a large Chinese community. (ICHS.)

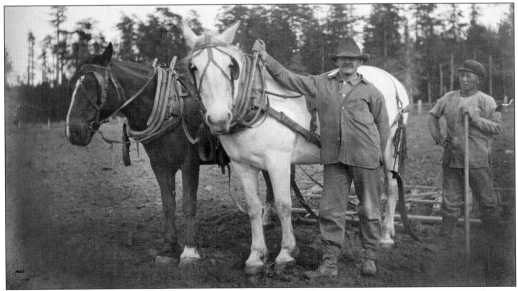

This photograph from the early 1900s shows Sam E. Hancock (left) and Johnny Gong, a Chinese man who worked on the farm from 1904 to 1920. Farmer E.J. Hancock, Sam's cousin, strongly denounced the Chinese Exclusion Act of 1882 in a letter to other farmers saying, "The Chinese, by industry, pay strict attention to their own business, and studying their employers' interest, have created a demand for their labor, and it is only justice that they be allowed to fill the demand." (UWLSC #19488.)

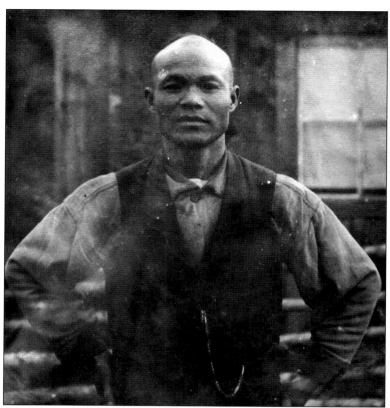

Lee Yu (Leo) worked on the E.J. Hancock farm. Chinese workers first came to America in the 1850s to work in California gold mines, moved to the Pacific Northwest during the gold strikes on the Fraser River in 1858, and worked building the transcontinental railroad. When railroad building was stymied by financial depressions in the 1870s and 1890s, they turned to agriculture. Lee Yu, like many others, may have stayed until he died or returned to China as an old man. (LH.)

other similar acknowledgements or ascertained liability.

At least a month from date hereof I intend to depart to China via the port of PUGET SOUND

with the intention of returning via your port within one year from such date of departure.

My photograph hereto attached is a correct and faithful likeness of me.

MY DESCRIPTION IS AS FOLLOWS:

Name Leo Ham

Local Residence Coupeville Wash

Age 46 years

Occupation Farmer

Hight 5 ft. 5 in.

Weight at present 130 pounds

Color of Eyes Dark Brown

Complexion Dark

Physical Marks Large Scars on right Side of Neck

No. Certificate of Residence 6638

Family Property or Debts Lew Yong of Seattle Wash owes me at

The US and Washington state governments regulated Chinese workers by requiring them to have certificates of residency, like this one. Leo Ham was 45 years old in 1900, according to records of immigration at the National Archives. (MP.)

Six

PRAIRIE CENTER

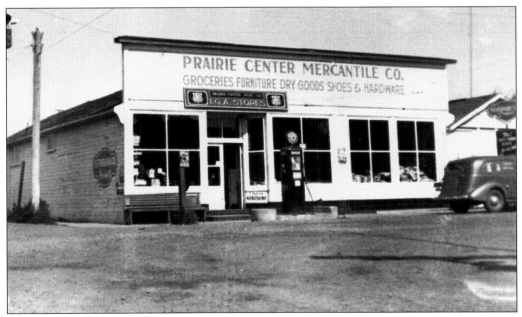

A mile south of Front Street is a store built by Sam Hancock in 1915 for Fort Casey soldiers Henry Fair and Oscar Hull. In 1921, Prairie Center Mercantile was purchased by Moritz Pickard and his brother-in-law Sam Gelb. Pickard and Gelb also marketed local farm products in Seattle, returning to their store with farm equipment, plumbing fixtures, and other items. (ELNHR.)

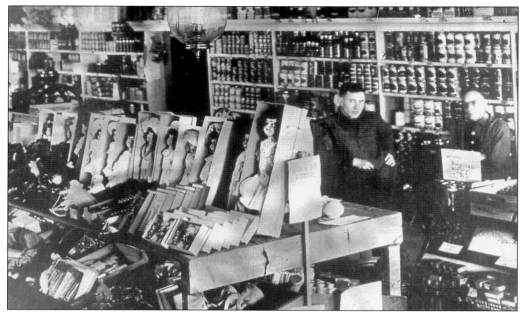

Sam Gelb and Moritz Pickard's merchandise appealed to all ages and genders. When Moritz's son Herb Pickard and Herb's wife, Muriel, took over the store, they continued extending credit to farmers until their annual crops were harvested and sold. Herb made buying trips to Seattle every Tuesday for 30 years. Their motto was, "If we don't have it, we can get it." (MP.)

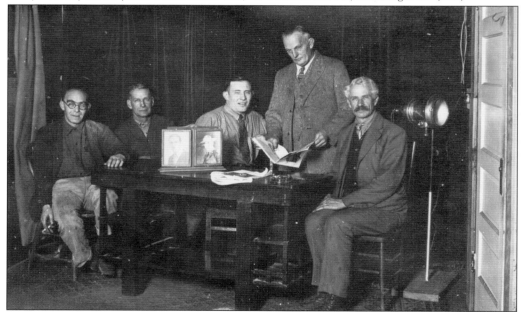

Meeting in Pat's Place (currently the Tyee) in 1928 are Prairie Center businessmen (from left to right) Moritz Pickard, Dick Willard, Sam Gelb, Pat Partridge, and Ronald Race. Dick's daughter Leone "Sis" Argent says the men met to talk about how to increase business and keep the dust down on the road. The solution to the dust was covering the road in oil from a five-gallon can with holes poked in the bottom. (LA.)

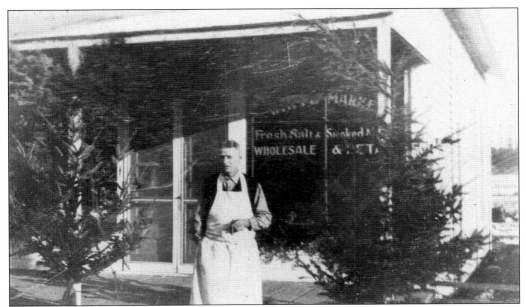

Dick Willard (above) built the Willard Race White (meat) Market at Prairie Center with partner Ronald Race in 1926. Dick was the beef butcher; Ronald specialized in sheep. Below, Dick and his son Stanley display some fake hams for Easter. After opening, barber Walt Stoddard built a barbershop on the north side of the market. The building was then moved north to accommodate Dean Motors on the corner of Main and Terry Road. The barbershop side was sold to barber Robert "Pat" Partridge and wife Florence. When the Partridges took over, they added a restaurant and rooms to rent and renamed the building Pat's Place. It is now known as the Tyee (meaning "chief" in Chinook), and the old meat market is the current Tyee bar. (Both, LA.)

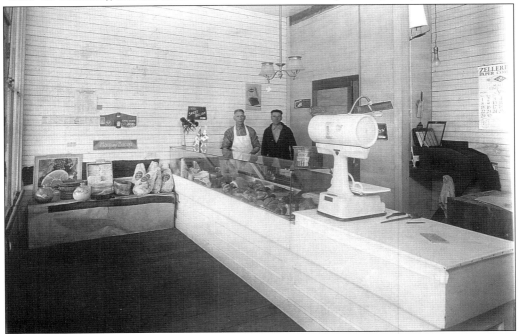

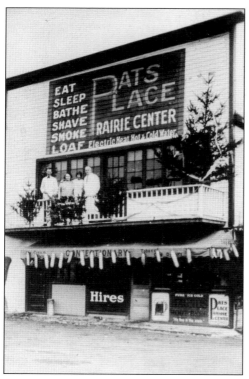

Pat's Place was where you could get it all—food, lodging, a shave and haircut, a bath, and a place to loaf. Overlooking Main Street from their second floor are, from left to right, an unidentified barber, "Mrs. Pat," Jessie Libbey Buckner, and Robert "Pat" Partridge. According to Herb Pickard, "Mr. Pat, who was retired military, gave orders. Mrs. Pat worked her heart out in the restaurant." This photograph was altered for an early widely distributed postcard to include the "Pat's Place" sign, which was actually on the back side of the building. (LA.)

Dean Motors was originally located behind Prairie Center Mercantile on Terry Road. Carl Dean later built a service station on the corner across from Prairie Center Mercantile because the corner offered more visibility. Dean sold Willys Knight and Whippet cars before starting a Chevrolet dealership. Pictured in 1939 are high school chums Janet Gelb (left) and Evelyn Parker. The intersection's blinking light, purchased and installed by the four Prairie Center business owners, remained the only one in town for years. (LH.)

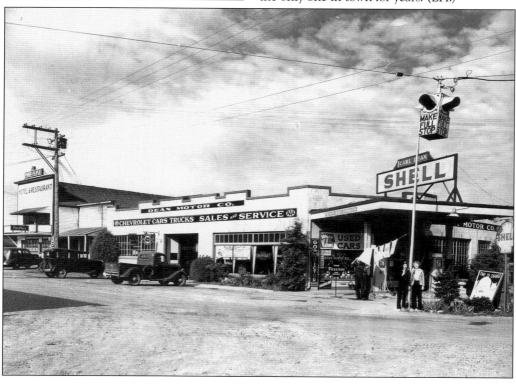

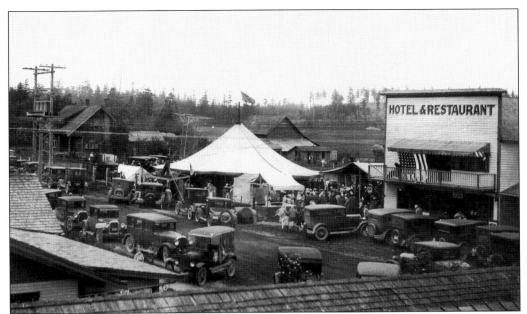

Market Day became a semiannual two-day Prairie Center event at Easter and Thanksgiving. The festivities brought people from all over the island for ball games, motion pictures, singing, contests, and an all-night dance at Dean Motors. In this photograph, a 1929 baseball game is in progress in the field behind the tent. On the left is the Newberry house, still in the Pickard family. (LH.)

Herb Pickard met Muriel Sarchin in Seattle, and they were married in 1942. Born and raised in Coupeville, Herb graduated from Oregon State College. While he served two years in the Navy, Muriel moved to Coupeville and helped her new family run the Prairie Center Mercantile business. According to Herb, "The country store was the center of everything," including their lives. Their children Jan and Ken were raised working in the store. (MP.)

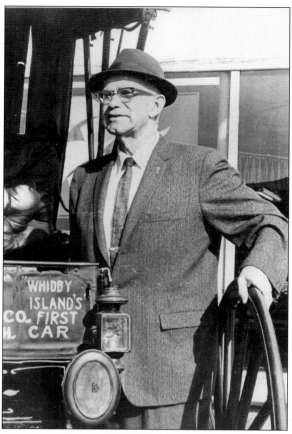

Pictured in 1950, Carl Dean, owner of Prairie Center's Dean Chevrolet, stands with his 1902 Holsman, the first car on Whidbey Island. Judge Still was the original owner, but he did not know how to drive it, so Dick Hastie was his driver. As this Holsman "autobuggy" could only go forward, it had to be turned around by pushing the wheels backward by hand. The vehicle could travel up to 25 miles per hour. After Harold Johnson and Hike Willard, Dean's garage mechanics, got the car in running condition in 1930, they gave rides at noon to some of the high school students. It is on exhibit in the museum. (ICHS.)

Pictured from left to right are Prairie Center's Herb Pickard, Laurence Reuble (friend), and Moritz Pickard enjoying a laugh in 1955. (ELNHR.)

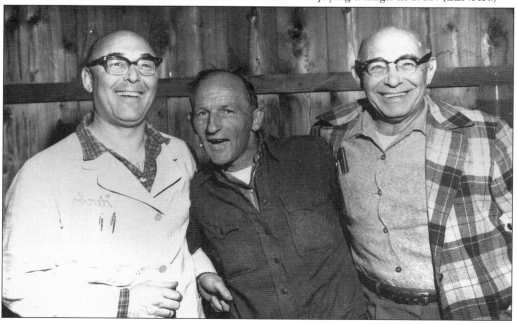

Seven

BASTIONS AND BEACONS

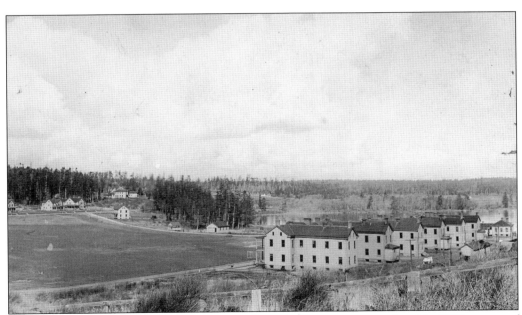

Fort Casey, named after Brig. Gen. Thomas Lincoln Casey, was completed in 1907 as one of three forts protecting the main entrance to Puget Sound. Its cantonment area is shown looking north from the lighthouse. In the right foreground are the enlisted company barracks. At its peak between 1909 and 1919, the fort included up to four companies with up to 102 men per company as well as additional general support personnel. (SK.)

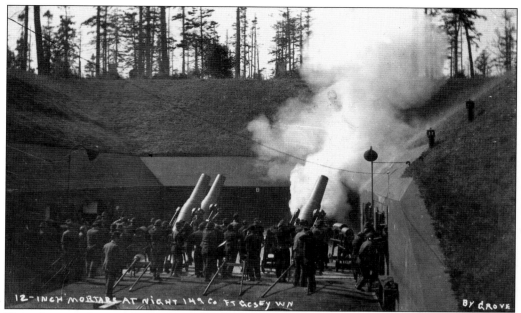

This photograph records Battery Schenck Pit B live fire practice. Fort Casey had two mortar batteries, Schenck and Seymour. There were two pits to a battery, and each pit included four M1890MI 12-inch mortars. The battery was well protected from the target area, where the projectiles rained down through the decks of ships. (SK.)

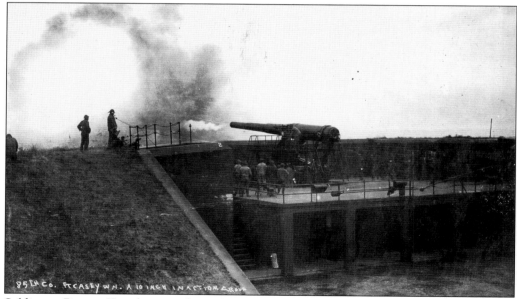

Soldiers at Battery Kingsbury are firing Gun No. 2, a M1988 10-inch gun mounted on a M1901 disappearing carriage. The image was taken from the parados bridge that protected the M1905 six-inch gun battery (Battery Valleau) located at left. Battery Kingsbury, manned by the 85th company, faced south and would target any enemy ships that successfully sailed past Admiralty Inlet. (SK.)

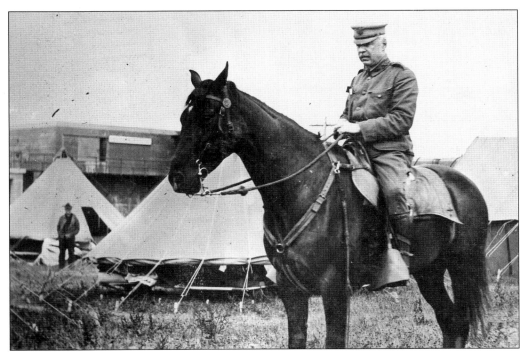

Colonel Hayden, commanding officer of Fort Casey, is conducting his required daily inspection tour of the fort. Officers had to provide their own horses and pay for grooming. This image was taken during one of the fort's encampments, which were conducted on a regular basis to keep troops trained for fort land defense. When funds were not available to conduct joint maneuvers remotely, each company encamped within the fort. (SK.)

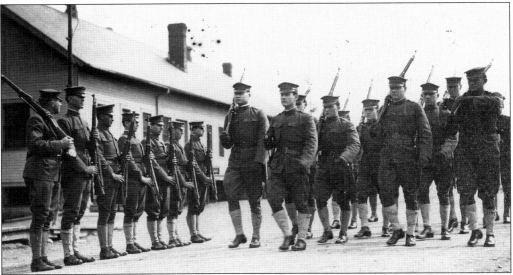

In 1915, these marching soldiers are coming off guard duty while the soldiers at attention are their replacements. The quartermaster building is in the background; the guardhouse is left of the image. The soldiers wore many mixed styles of uniforms from 1908 through 1912 because uniforms were replaced as needed or available, not when regulations changed. (SK.)

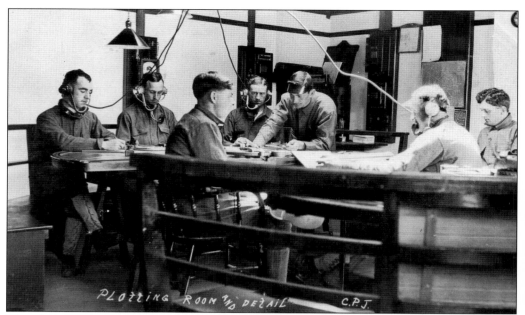

This photograph shows a typical plotting room for mortars in Puget Sound. Estimated range and direction of the target at designated time intervals were sent to the plotting room from fire control telescopes. The plotting room calculated the final speed, direction, and range of the target from the mortars. The final elevation and azimuth setting were then sent to the mortars to ensure the projectile and the target met at the same place and time. (SK.)

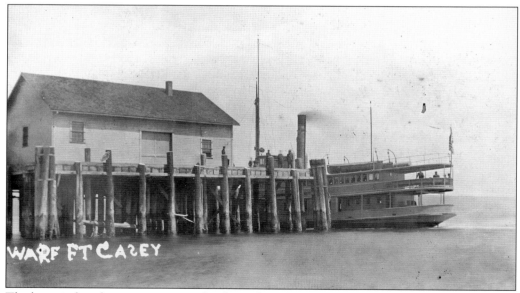

The boat tied to the quartermaster wharf in Admiralty Inlet at Fort Casey is the vessel *Thomas*. Contracted to the US Army, it served as part of the Harbor Boat Service Puget Sound and was operated by the quartermaster corps to ferry supplies, troops, and mail between Puget Sound forts and Seattle. The quartermaster wharf also included the Lifeboat Service House (not shown), forerunner of the US Coast Guard. (SK.)

As it is today, playing music was a real morale booster and a popular pastime for soldiers. Here is a duet pretending the bed is a stage, hamming it up for whoever might listen. (SK.)

This photograph is probably a setup shot dating after 1905 and was likely taken on a Sunday in the barracks. The typewriter (Smith Premier Model 2) normally would have been used in the fort's administrative offices. The "typist" and his cronies appear to be pretending to be newspaper men; the pipe and whiskey bottles typified correspondents of that era. Alcohol was forbidden in the barracks so the bottles *should* have been empty. (SK.)

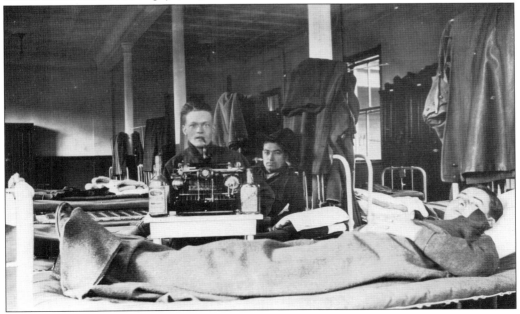

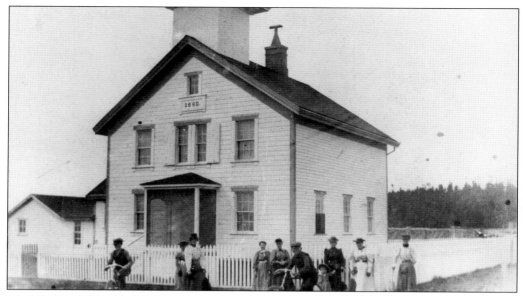

The Red Bluff Lighthouse was built in 1860 at Admiralty Head and cast its light in 1861. Capt. William Robertson, father of Coupeville businessman John Robertson, was appointed by Pres. James Buchanan as the first lighthouse keeper (1859–1864). William took out a Donation Land Claim at Admiralty Cove. Robertson family members continued to live at the farm called Lea Bluffs until 1898 or 1900. Daniel Pearson was appointed lighthouse keeper in 1864; his daughter Flora worked as assistant keeper and wrote the monthly report to Washington, DC, until 1878. (LS.)

William B. Engle and Flora Pearson Engle (assistant lighthouse keeper), who married in 1876, posed for this photograph in 1907. Engle arrived in Penn Cove in 1852 aboard the *Cabot* sailed by Capt. Thomas Coupe. He took out a Donation Land Claim and became a successful farmer. Flora, who arrived at age 15 on the second Mercer expedition, kept diaries all her life that are still used for historical research. (JEB.)

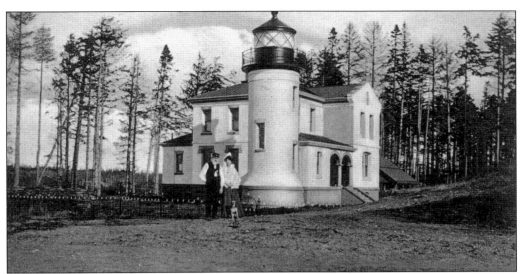

This photograph shows keepers Charles and Delia Davis in front of the second lighthouse, which was first lighted in 1903 and discontinued in 1922. In 1941, the lighthouse was surplused, used by the Coast Guard and Army, and then abandoned. Local history buffs Pat Wanamaker, Jimmy Jean Cook, Inger Mathews, Lillian Huffstetler, Irene Wanamker, Ron Van Dyk, and Evelyn Johnson recognized it as the jewel of the fort and worked to preserve it. Washington State Parks acquired it in 1956. (RS.)

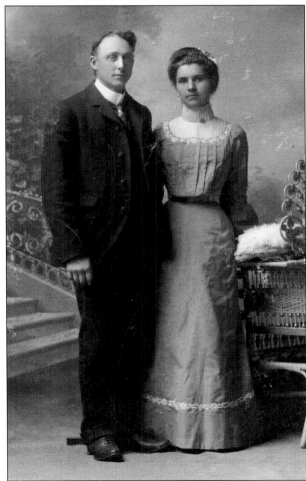

This photograph features George Wiley Jr. and Anna Voss Hesselgrave. In 1902, Wiley's first enterprise was running Keystone Sand and Gravel on the west side of Whidbey Island. (See next page.) The *Keystone* name was chosen in 1912, either as the "Key to Puget Sound" or because "stone was the key to all good construction." Anna had cows and chickens, sold butter and eggs, and designed and made rugs. When she could not find a crochet hook large enough, she carved her own. (JEB.)

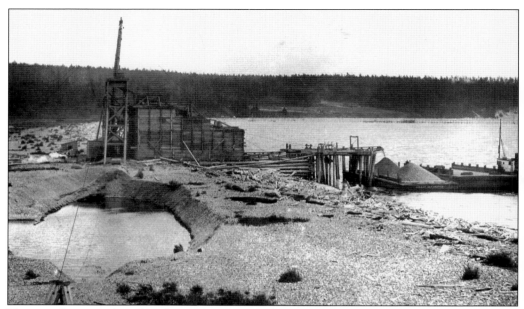

Keystone Spit was platted in the 1890s as "New Chicago" and "Brooklyn," and a bridge was built across Crockett Lake; the pilings remain. After a few of the lots were sold, the project fizzled. According to historian Theresa Trebon, the Keystone name was advertised as the "Keystone to Puget Sound" at the 1909 Alaska Yukon Exhibit in an effort to reignite the real estate plans for the land. Keystone Sand and Gravel was near the present-day Port Townsend/Coupeville ferry terminal. In 1914, George "Wiley" Hesselgrave moved to Coupeville to run the company. Keystone gravel was used to construct some Seattle buildings, including the Olympic/Fairmont Hotel and Smith Tower. (JEB.)

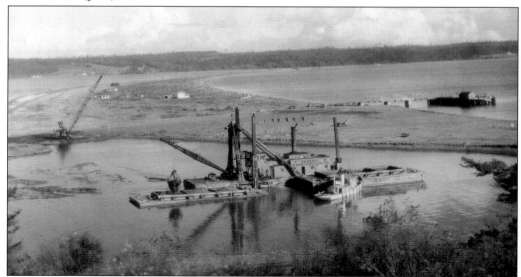

Dredging was underway in this photograph taken around 1947 at Keystone Spit in preparation for a ferry landing that would offer car and passenger service between the west side of Whidbey Island and the Olympic Peninsula at Port Townsend. The Quartermaster Wharf is visible at right. (FB.)

Eight

COMMERCE ON THE COVE

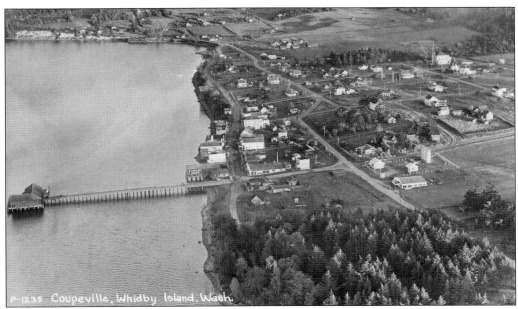

This aerial photograph taken in the 1940s shows Coupeville as a small town surrounded by farms and forests. The only remaining wharf of the five known to have serviced Coupeville still stands as testimony to the importance of transportation by water. The triangle made by the street cutting diagonally across from Coveland Street to Ninth Street in the center is the current Cook Park. In the northwest corner of the triangle was the first primitive automobile service station. The diagonal road no longer exists. (RS.)

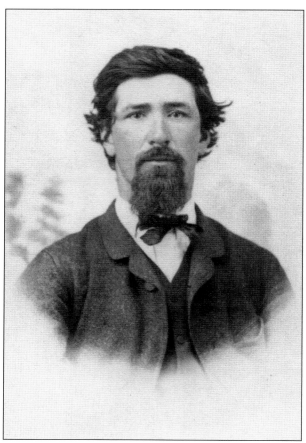

John A. Robertson arrived on Whidbey in 1853 and bought part of the Alexander Donation Land Claim. Not long afterward, he built the first wharf in Coupeville at the foot of Main Street and many buildings on Front Street, most of which still stand. This dock was built by Robertson in 1883 and abandoned in 1909. A highly respected man, Robertson served as Island County sheriff for a few years. Robertson died in Nome, Alaska, in January 1917 after being hit by a mast while dismantling a ship. Below are, from left to right, Oliver Van Olinda's telegraph office and tower*, the Bank of Commerce, a furniture and hardware store*, Puget Race Druggist, Sedge Building, the public library*, the three-story Glenwood Hotel, Puget Sound Academy* (on the hill behind the hotel), the Robertson House (occupied by both John and his father William Robertson and later Brosseau's Six Persimmons Restaurant), and Whidbey Mercantile (now Toby's Tavern). (*These buildings no longer exist.) (Both, ICHS.)

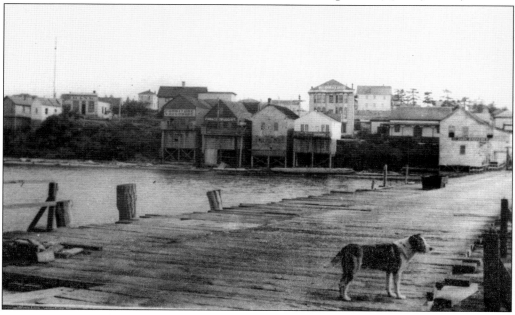

This view of Front Street from the west is from a 1917 calendar. Residents were able to take advantage of the thoroughfare from the town park up the hill. (LH.)

COUPEVILLE WASH

This early 1900s photograph shows Coupeville from Parker Road looking west. The long building at center right is the Lovejoy lumber mill. The cylindrical structure on the waterside is the "waste burner" that was used to incinerate sawdust. (ICHS.)

COUPEVILLE, WN. LOOKING WEST.

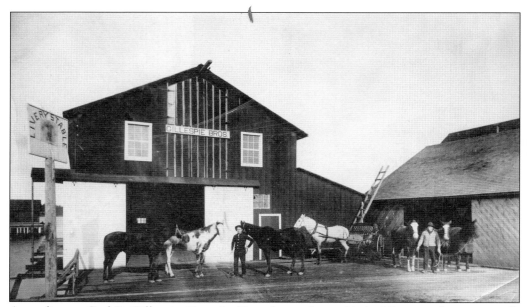

According to Carl B. Gillespie, Captain Coupe's grandson, this building was first a sawmill. Charles Terry converted it into a fruit dryer in 1897. The business processed locally grown fruits and vegetables for shipment to the Alaskan goldfields. James Gillespie purchased the building in 1908 for use as a livery and feed stable operated by his sons Laurin (left) and Carl (right). Visitors could arrange for horses and carriages when they came to Coupeville by boat. (ICHS.)

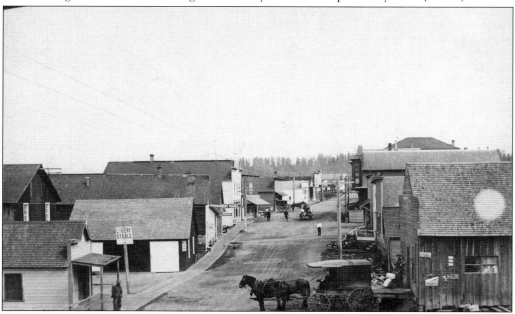

The wooden structure at right in this early image was later replaced by the Cushen Garage. Perhaps the man on the porch is loading bags of grain into the parked delivery wagon. Only men can be seen, although the wooden sidewalk on the left-hand side of the street would have made navigating the dusty or muddy street much easier for ladies. Flora Engle was an early proponent of sidewalks so "ladies' dresses don't have to get dirty." (ICHS.)

In front of Whidbey's Mercantile (currently Toby's Tavern) in 1896 are, from left to right, the horse Kit with Alonzo Coates, Selma Coates, Joshua Highwarden, and Sheriff Comstock. The building was constructed for John Robertson in 1875. The building's east portion was used as a store by a variety of owners until 1938. In the 1930s, George Hesslegrave had a plumbing business, sold gasoline, and had a vehicle for hire on the west side of the building. (ICHS.)

John Jacob "Jake" Straub was born in 1847 in Kingston, Ontario. He and his wife, Mary Ann Waterworth, had eight children. Jake purchased this blacksmith shop at Front and Haller Streets in 1884. He was a popular blacksmith, doing everything in the line of horseshoeing, and was an agent for wagons, carriages, hacks, and farm machinery. He and his crew also built wagons and buggies. (ELNHR.)

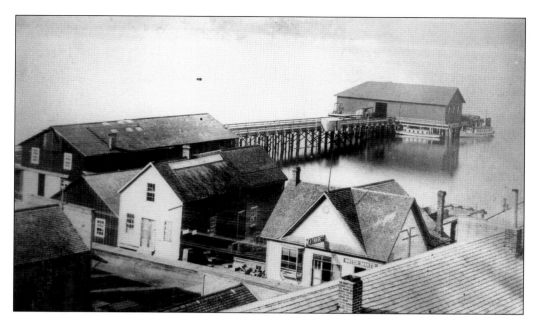

The photograph above, taken from the roof of the Central Hotel, shows the meat market and watchmaker businesses in the Sill house. The house presently sits on Coveland Street. To the left of that is where the *Island County Times* began before moving across the street. Gillespie's Livery is farther left. Neither of the two center buildings survive. Elmer Calhoun owned the Coupeville dock and wharf and operated a grain-cleaning machine. Local children found much entertainment at the wharf; Calhoun allowed them to climb on sacks of grain and jump off the roof and railings into the water. Floats on the east side of the wharf served as a place to fish for pogies using worms on pieces of string. The pre-1926 photograph below shows the Central Hotel and a late-teens Model T Ford roadster. (Both, ICHS.)

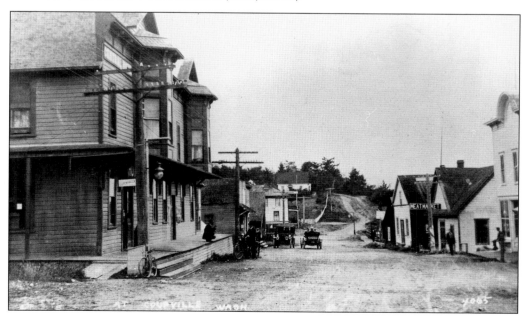

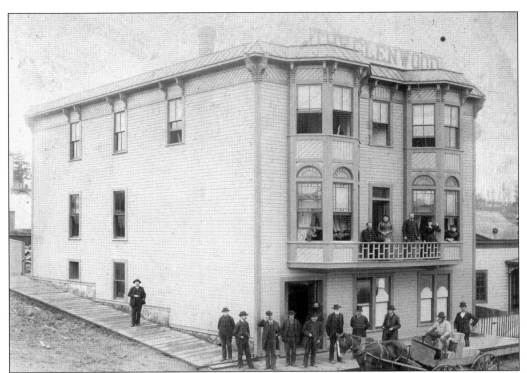

After the widening of Main Street, John Robertson contracted with 25-year-old Chris Fisher to construct the Glenwood Hotel on the corner of Main and Front Streets. In 1891, Fisher met and married Sibella "Sibbie" Barrington. Because they did not want to raise children in a hotel with a saloon, they sold it to Thomas Calhoun in 1892. The street-level part of the building has been used for a wide variety of businesses. Chris and Sibbie Fisher are pictured on the balcony at left, Nellie Morse Dyer is in the window, and Joe Goodwin is in the downstairs doorway. (ICHS.)

Elmer Calhoun bought the Glenwood Hotel from his parents in 1895. While Calhoun worked in the Alaska goldfields, he leased the hotel to Charles Hoyt, who was fined for serving liquor to Indian Charlie Snakelum. After the trial, Snakelum was paid a $2 witness fee. Later, Calhoun returned to rent rooms in the hotel and renamed Calhoun Towers and then Calhoun Apartments. Calhoun also served as the mayor of Coupeville. (ICHS.)

Francis Puget Race has been described as "a successful businessman and one of Coupeville's most earnest workers." He came to Whidbey Island in 1876 and dealt in real estate as well as being a popular druggist. "He owned a fair amount of property in and around Coupeville," according to Sally Race Thompson. Puget Race knew about natural and prescribed remedies and was able to provide medical help to many. (ICHS.)

This building was constructed in 1890 as F. Puget Race's drugstore. The level below the street was occupied by Will Tenney, a shoemaker who also repaired and cleaned guns and sewing machines. Before he married Hattie Swift, Puget lived in the upper part of Gaston's store across the street. When the road crew sheared through the building during road widening, his room was quite exposed. (ICHS.)

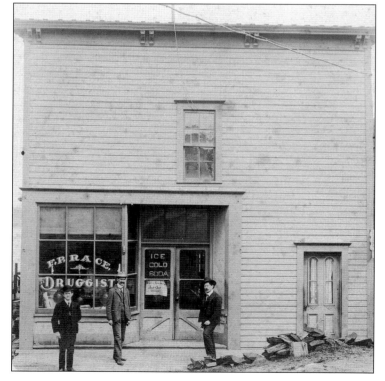

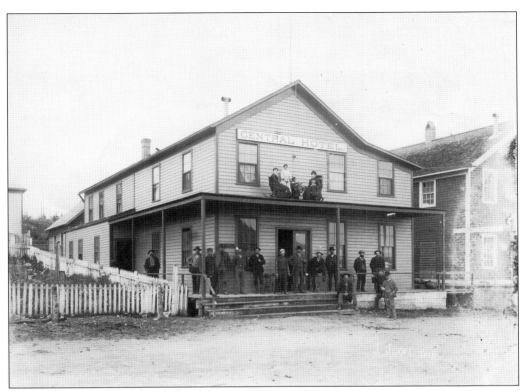

The Central Hotel with bar, billiard room, and livery stable was owned by Jacob Jenne in 1886. Jenne was repeatedly nagged by his Masonic brothers for selling liquor. He later annexed the Good Templars' Hall to the hotel. C.C. Cushen bought the Central Hotel from Jenne's estate in 1904 but was not admitted to the Masons until he had sold the hotel and saloon and built the Central Garage. (ELNHR.)

Charles Colvert (C.C.) Cushen, born in 1870, homesteaded in Coupeville in 1894. He went to Alaska during the Klondike gold rush as a merchandiser, and then followed Dutch farmers from Hagerstown, Maryland, to Whidbey. At age 24, he owned everything on the south side of Front Street from Alexander Street past Grace Street. According to grandson Bob Cushen, "He didn't like the waterfront and thought it would slough off into the water." (BC.)

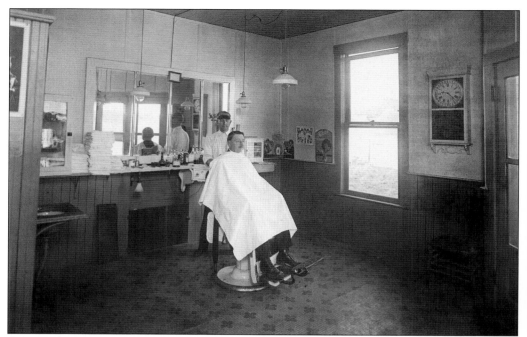

C.C. Cushen gets a trim in the barbershop in the northwest corner of the Central Hotel. (BC.)

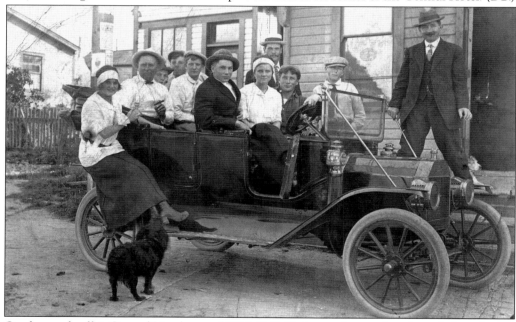

On the porch of his Central Hotel around 1920, C.C. Cushen welcomes friends, including George Morris, Charles W. Straub, Carl Otto, Hazel ?, Irene ?, Carl Gillespie, and Owen Lovejoy. In 1925, Cushen built the Central Garage on the corner of Alexander and Front Streets and sold the first Ford Model Ts. The automobile ferry at Deception Pass foretold the end of steamships, eliminating the need for the Gillespie Livery Stable and contributing to the success of Cushen's automobile business. (BC.)

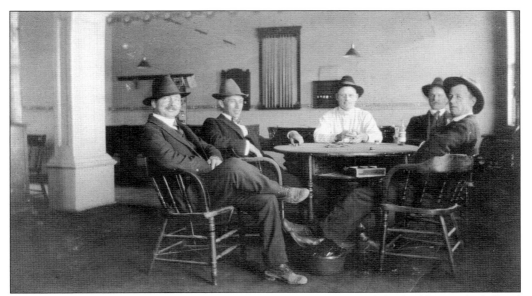

C.C. Cushen (left) presides over what looks like a game of cards with his buddies in the billiard room of his Central Hotel in 1924. (BC.)

Card playing on the porch of the Central Hotel was a good way to while away the time in early Coupeville. (LA.)

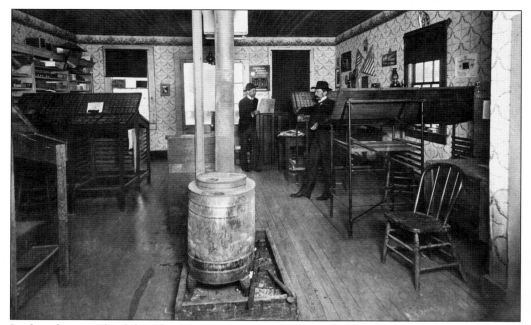

In this photograph of the *Island County Times* office in 1903, Carl Pearson (left) and O.S. van Olinda are seriously considering what news to bring to the people. The office moved around in several buildings; perhaps this office was in the current McGregor Building on Front Street, where metal type can be seen lodged in the floorboards today. (UWLSC#19498.)

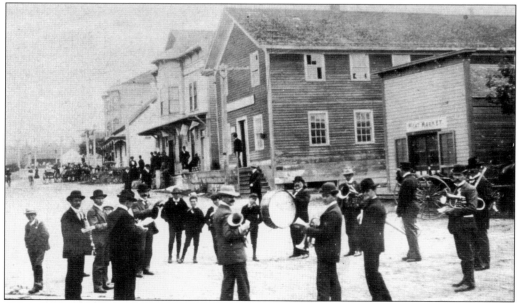

These unidentified town band members are warming up in this 1890s scene. The meat market was later moved, used as the Abstract Office, and is currently Kapaw's Iskreme. The two-story building at center is the Good Templars Hall, the first fraternal organization in Coupeville. Its Front Street building became a popular place for plays, lectures, speeches, and dances in the mid-1860s. It also accommodated meetings of the WCTU and county commissioners. (ICHS.)

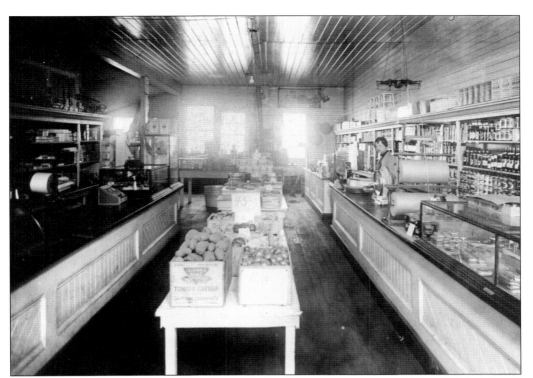

Elva Hesselgrave awaits customers with Whidbey Mercantile's ready supply of food and merchandise. Relative Joanne Engle Brown remembers, "Bananas came packed in 50 gallon barrels, complete with the stalk and packed in excelsior. They hung the whole stalk on the east wall, and with a linoleum knife you cut off the bananas you wanted." Built by John Robertson, the building is the current Toby's Tavern. (ICHS.)

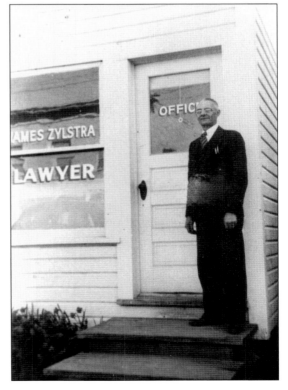

James Zylstra's first law office was on east Front Street. In 1933, he bought this building on the west end of Front Street, which was constructed by Jacob Straub for Judge Lester Still. In 1902, Zylstra was elected county clerk and served four years until 1906. He served as Island County prosecutor and was a state representative from 1919 to 1922. He was the mayor of Coupeville in 1913–1918 and again in 1921–1927. (ICHS.)

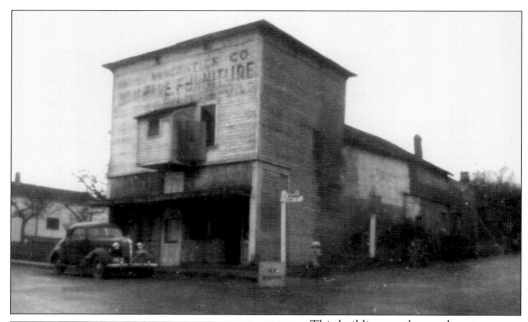

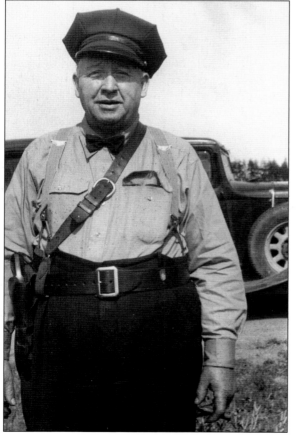

This building on the southeast corner of Front and Main Streets (originally known as the Brunn or Haller store) was an "obstruction" that was sliced in half in 1889 to widen Main Street. The remains of the store became the Circuit Theater. Its projection booth hung over the sidewalk on Front Street. George "Wiley" Hesselgrave bought the building and ran the theater from 1926 until 1939. He made a weekly trip to Seattle in his Studebaker to exchange films, also hauling freight and passengers, including a claw-foot bathtub. The piano used during silent films is still in the family. After Hesselgrave closed the theater, he worked as a Pinkerton Agency security guard. Wiley, rarely without a cigar, loved his seven-passenger Studebaker with its "jump-up" seats. After Hesselgrave died in 1946, his heirs razed the "Show House." (Above, PD; left, JEB.)

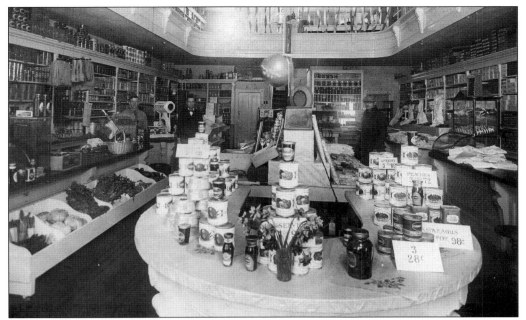

The Blowers and Kineth building remained a general mercantile store, operating as the Coupeville Cash Store and later as L.N. Sill's Grocery. It is shown in 1925 with owner Nels Sill (far left) and clerk Charles Straub (center left). Buildings such as this one often had residences on the top floor. This mezzanine was converted for that use. Ralph and Charlotte "Lottie" Lindsay opened Lindsay and Son Sure Fine Grocery in 1944. When the Lindsays moved their store, Harry Hurd opened Coupeville Pharmacy here. The building has since housed several retail businesses. (ICHS.)

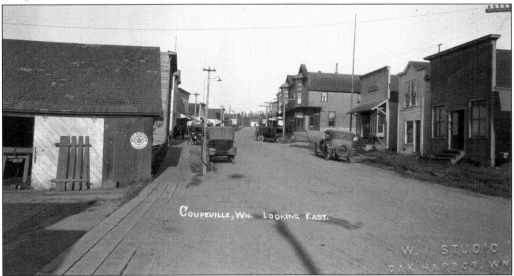

In the early 1930s, boardwalks stretched along Front Street. The building on the right is the 1906 home of the *Island County Times*, next is the 1909 Judge Still Law Office, and the building with the porch roof and the first facade on Front Street is the Elkhorn Saloon. Pharmacist Joshua Highwarden raised the height of its door to accommodate his top hat. The building later housed Coupeville's first post office. (ICHS.)

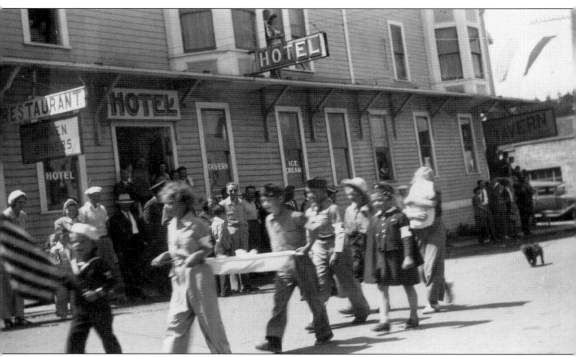

This August 1942 parade occurred the last year of the original Coupeville Water Festival. Bill Engle, the "sailor" in front, stretcher carriers Jeanne and Bill Truex, and Babe Alexander and Joanne Engle (in dark coat and hat) represent the military and Red Cross. The Good Templar's Hall had been moved and connected to the Central Hotel in this photograph. A bay window had been added to the Good Templar's Hall building to tie the two together. The building burned in 1944. The beautiful bar that had reportedly been shipped around Cape Horn and the "Tavern-Rooms" sign were rescued from the hotel and moved across the street to the Coupeville Cash Store building by Vic Sealey for his tavern. The tavern was renamed Toby's Tavern by Hank Tabach in 1971. The lot where the hotel and hall were was left vacant until a new building was constructed in 2000. The cement block building on the right was constructed by Ralph Ward in 1938 as a post office. It later became a laundromat and retail stores. (JEB.)

Ilah Lindsay Engom (age 19) bought the Fort Casey Dry Cleaners (located in the Calhoun Building) in 1941, paying the owner $1. She is standing proudly with her 1934 Chevrolet in front of her business. On the right are the Coupeville Cash and Carry (Toby's Tavern), Wiley Hesselgrave's plumbing business, and Wiley's Service in what is now Toby's Kitchen. Wiley operated three gas pumps that were located on the unpaved street and a single gas pump in front. (IE.)

In 1917, the public library (right) opened its doors in this Front Street building. Support from Frank Pratt, Ladies of the Round Table, and a donation of books started this community institution. In 1928, the Whidbey Island Library Association donated the library to the City of Coupeville. The building was also used for town hall meetings. Later, it was reportedly bulldozed onto the beach by Mayor Ralph Ward. (Note the "Tavern-Rooms" sign on Sealy's Tavern.) (IE.)

This store was built on the site of the Sill house by Sam (second from right) and Nellie Benson as a gift store and confectionery in 1916. Thelma Howard operated a liquor store and confectionery there in the 1940s and 1950s. All over-the-water buildings on Front Street had toilets that emptied onto the beach. This building (Kingfisher) contains the only remaining one. The tide flushed twice a day. (ICHS.)

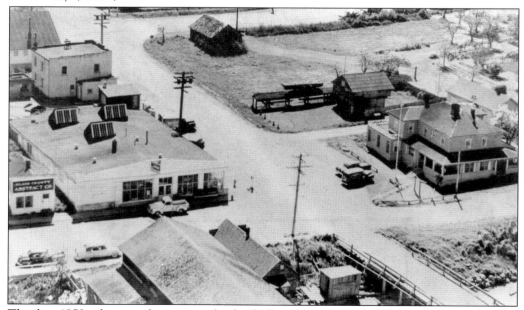

This late-1950s photograph captures the fire hall and recreation hall (upper left), the Cushen Garage (just below them at center left with a white truck in front), and Terry's Dryer, currently Windjammer (at the bottom). The Alexander blockhouse and canoes are at center right, the Starwana Hotel with two vehicles in front is at lower right, and the approach to the wharf is at bottom right. The shed at top center has been demolished. (ELNHR.)

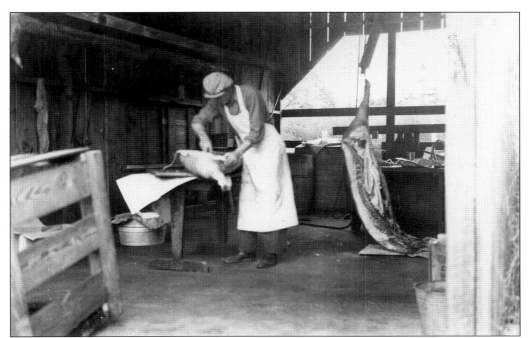

Shirley Parker, co-owner of the Parker and Capaan Meat Market in the Blowers Kineth building, cuts meat in preparation for sale. Parker was also a postmaster and served as Coupeville's mayor from 1928 to 1931 and again from 1934 to 1940. (Diane Eelkema.)

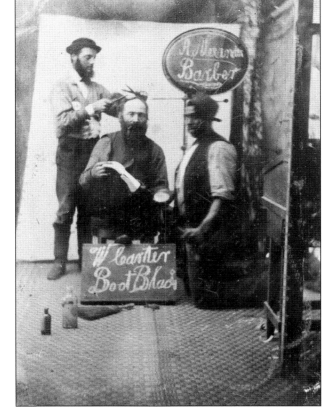

According to the inscription on the back of this photograph, "Carter was a blacksmith, originally from Canada. Alexander owned a hotel." The three men were posing as a joke: Kinney as the customer, Carter as the bootblack, and Alexander as the barber. (ICHS.)

Vic Sealey stands in the doorway of Sealey's Tavern after he converted the Whidbey Mercantile/Coupeville Cash and Carry building in the 1940s. Sealey's marriage was known as a "marriage of convenience" in order to buy the tavern. His wife and her mother lived where the current kitchen is. During Vic's ownership of 17 years, the tavern had a bar, jukebox, and pool table, but not many women customers. Sealey later served as mayor. (Barbara Reed.)

The small, single-story building (left) constructed by W.C. Cheney on the beach below the Cash and Carry was the first power plant in Coupeville. Legend has it that after Shirley Parker, co-owner of Capaan and Parker Meat Market, opened his business, he turned on the power each morning to provide electricity to Front Street merchants. (ICHS.)

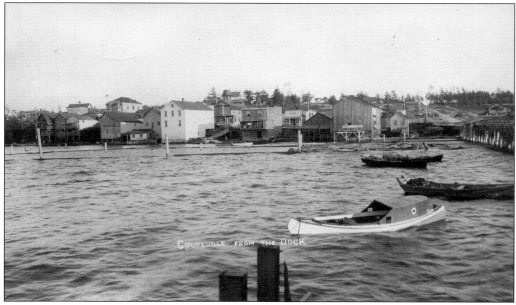

C.C. Cushen sold his garage and Ford dealership in this building he had constructed to Al Sorgenfrei, who moved his Pontiac dealership to Coveland Street in the 1930s. Other occupants of the building, currently Mariner's Court, included Sullivan's restaurant, a creamery, cold storage lockers and a meat market, the Lindsay Grocery, and later, Lindsay's Marina. The blank artillery shell on the corner was fired during a practice shooting at Fort Worden across Admiralty Inlet. Rescued from the Krueger field nearby, it was mounted in the sidewalk. (ICHS.)

John Alexander's widow, Frances, married ship captain and government Indian agent Robert Fay, who opened Mother Fay's Inn in 1870. The hotel was also known as the Pioneer, State, and later, the Starwanna, under the ownership of Harry Stark and Elva Wannamaker Stark. Marilyn Sherman Clay remembers asking Elva, "What's the oldest thing in here?" She said, "Me, honey." The hotel, which later became the Blockhouse Inn, burned in 1968. (ICHS.)

The recreation hall is visible on the far right in this photograph. Local women organized by Grace Sherman and aided by Anna Roosevelt Boettiger asked for the building, which had been surplused from the Grand Coulee Dam project. It was disassembled, barged, and trucked to Coupeville in 1942. Once a United Service Organizations Hall, it continues to be used for countless activities. The diamond-shaped windows in the front of the former fire hall were rescued from the burned Blockhouse Inn. The fire hall building temporarily housed the museum. (ELNHR.)

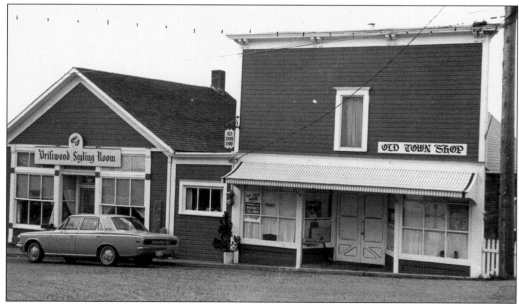

John Robertson sold this building (left) on the waterfront in 1890 to A.J. Sedge, an undertaker and merchant. After Sedge's wife died in a flu epidemic, he sent for his "sister" to help him close the business. She was really his wife, revealing his bigamy and original name of Blocksedge. In 1909, F.P. Race built the first telephone office between his drugstore (right) and the Sedge building. (ICHS.)

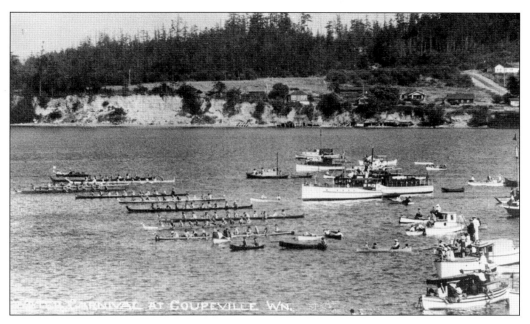

Wiley Hesselgrave (page 112), along with other Coupeville merchants, touted the island as a wonderful place to visit. In 1927, he invited Native Americans and First Peoples of Canada to participate in a Water Festival, promising them potatoes and a full tank of gas from Whidbey Mercantile/Cash and Carry. The first Coupeville Festival with Indian canoe races took place in 1930. Only three 11-man canoes raced then; in later years, up to 22 tribes attended the festivals with most participating in the races. Parades, sack races, pie-eating contests, and tribal dancing added to the festivities. A greased-pole contest and bone games took place in Town Park. Island residents baked bread as gifts for the Indian families. Both photographs, taken in the 1930s, indicate sizeable crowds that arrived from all over the Northwest by car, private launches, and sight-seeing excursion boats. (Both, ICHS.)

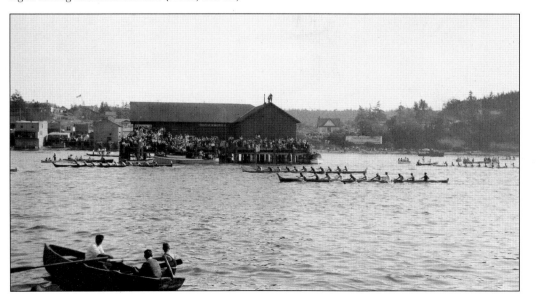

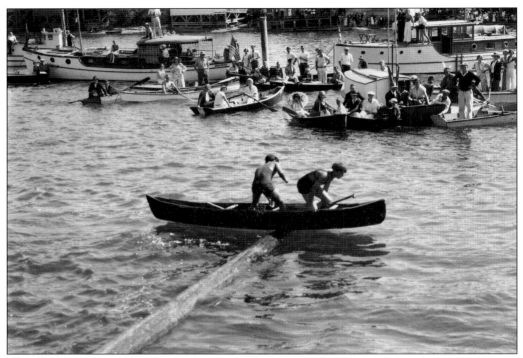

These Indian men are "hurdling" a canoe at a Water Festival contest sometime between 1930 and 1932. The canoe was paddled up a greased log anchored along the race course. Speed and timing had to be perfect; just as the canoe reached the log, the paddler threw his weight backwards, lifting the bow high enough to top the log. Then with a powerful stroke, he threw his weight forward to slide the canoe over the log and keep it upright to win the race. (UWLSC #29648.)

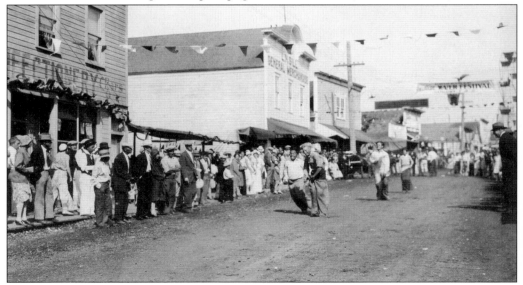

An enjoyable aspect of the Water Festival activities was the ethnic mix, as evidenced by the competing sack racers and onlookers. The wooden sidewalks and unpaved street indicate this photograph was most likely taken in the early 1930s. (DE.)

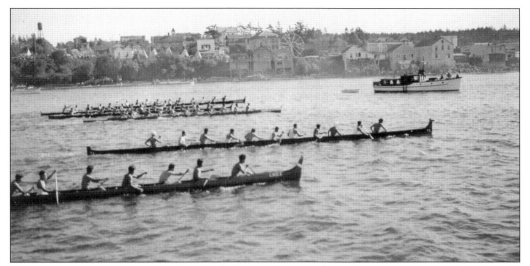

Indian canoes held 10 to 12 pullers, and these are slicing through the water in the final leg of a race watched carefully by the judges in the boat to the right. Visible are a Ferris wheel and five tepees on Front Street and large crowds on the bleachers behind Whidbey Mercantile and along the beach. The festival was shown on movie "shorts" all over the nation as an example of one of America's outstanding cultural events. The movie is still available at the museum. (ICHS.)

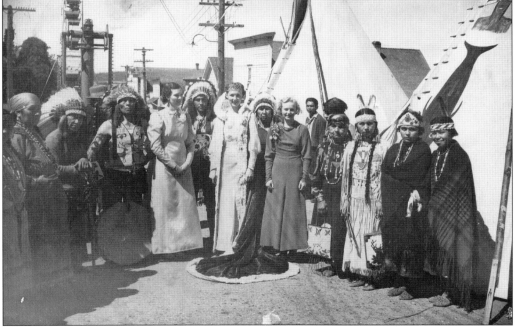

Tepees from the Yakama Tribe provide a backdrop for the unidentified Water Festival royalty. Feathered headdresses worn by Indians at the Water Festivals were not indigenous to Puget Sound tribes, but were traditional for the Yakamas from eastern Washington. The Ferris wheel was a popular attraction. Ron Van Dyk recalls, "They were shooting off fireworks and lobbed a skyrocket into a power line, which cut off the power all over town. People on top of the Ferris wheel were yelling, 'How are we going to get down?' because it stopped it cold." (MP.)

A photograph booth at the Water Festival around 1940 was used to capture Wiley Hesselgrave and two of his Yakama friends from the Plateau area of eastern Washington. Hesselgrave was highly respected by members of many Native American tribes because of his fairness and generosity. (Bill Engle.)

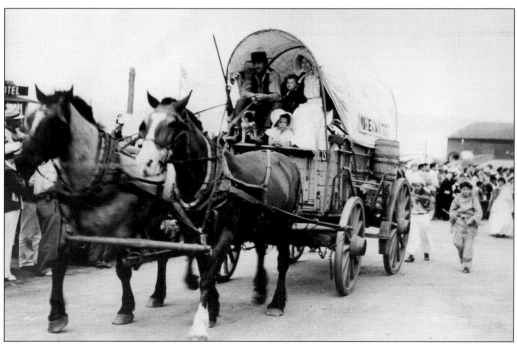

William Carl "Bill" Engle drives his horses Sam and Jerry in the 1939 Water Festival parade. In the covered wagon are Anna "Anne" Hesselgrave Engle, their children, William "Billy," Joanne, and their dog Skipper. Bill built the curved supports that hold the canvas, and Anne made the dresses and bonnets for Joanne and herself. (JEB.)

Nine

PROTECTING A TREASURE

The bluff along Ebey's Landing offers a spectacular view of the Olympic Mountains to the west, the Cascade Range, including Mount Baker, to the east, and on a clear day, Mount Rainier far to the south. From the top of the bluff is a scene of patchwork-quilt-like fields and a view to Port Townsend and Canada across the waters of Puget Sound. Accesses to the bluff walk are from the beach and a trail from Sunnyside Cemetery overlook. Visitors from all over the world are attracted to this special place. (Mitch Richards.)

Through Ebey's Landing National Historical Reserve, conservation easements have allowed the preservation of land so it will continue to be farmed while remaining in private ownership as it has been since the mid-1850s. Some farmers of Central Whidbey still plow Donation Land Claims established by their families a century and a half ago. This photograph captures farmer Dale Sherman on his tractor in a field of barley with Ebey's Ferry House and Admiralty Inlet as backdrops. (Mitch Richards.)

Coupeville's two-block-long Front Street continues to incorporate the new with the old. An antique car show in 2011 brought out residents' favorite vehicles of days gone by. The two facades on the left are the front of the newly constructed Front Street Grill, designed to fit in with the existing architecture. To the right is Kingfisher bookstore in the Benson's Confectionery building; next is the Blowers and Kineth building with the original John Robertson store to the right. (M. Denis Hill.)

BIBLIOGRAPHY

Cook, Jimmy Jean. *A Particular Friend, Penn's Cove*. Coupeville, WA: Island County Historical Society, 1973.

Darst, Peggy Christine. *Step Back in Time, a Photo Journey of Whidbey's Island and a Saga of an Irish Pioneer Family*. Coupeville, WA: Peggy Darst, 2004.

Ebey's Landing National Historical Reserve. *Building and Landscape Inventory*. Coupeville, WA: National Park Service, 1983.

Ebey's Landing National Historical Reserve, Coupeville, Washington. Oral history interviews by Theresa L. Trebon, 1995–1999.

Engle, Flora Augusta Pearson. *Recollections of Early Days on Whidbey Island*. Original weekly columns in *Island County Times*, January 1928–November 1929, scanned, edited, and published by Joanne Engle Brown, 2003.

Evans-Hatch, Gail E.H. and Michael Evans-Hatch. *Historic Resources Study, Ebey's Landing National Historical Reserve, Whidbey Island, WA 2005*. Seattle, WA: National Park Service, 2005.

Hayton-Keeva, Sally. *Ancestral Walls*. Coupeville, WA: Sally Hayton-Keeva, 2003. (A compilation of articles first appearing in the *Coupeville Examiner* from 2000 to 2003.)

Kellogg, George Albert. *A History of Whidbey Island*. Coupeville, WA: 1934.

Kidd, Anne. *A Barn Survey: Understanding the Farm Complexes on the Ebey's Landing National Historical Reserve*. Eugene, OR: University of Oregon Press, 2008.

Rose, Mary Kline. *A Great Blessing*. Coupeville, WA: United Methodist Church, 2003.

Sheridan, Mimi, AICP with McConnell/Burke, Inc. *How Coupeville Grew: A Short History of Town Development*. Coupeville, WA: Town of Coupeville, 1998.

Sherman, Capt. Roger M. *The Sinking of the Calista*. Coupeville, WA: Roger M. Sherman, 1998.

Trebon, Theresa L. *A Common Need, Whidbey General Hospital and the History of Medical Care on Whidbey Island 1850–2000*. Coupeville, WA: Whidbey General Hospital, 2000.

Whidbey Island Chapter #6 of the Daughters of the Pioneers of Washington. *Children of the Pioneers*. Coupeville, WA: Whidbey Island Chapter #6 of the Daughters of the Pioneers of Washington, 2005.

White, Richard. *Land Use, Environment, and Social Change*. Seattle, WA: University of Washington Press, 2008.

DISCOVER THOUSANDS OF LOCAL HISTORY BOOKS FEATURING MILLIONS OF VINTAGE IMAGES

Arcadia Publishing, the leading local history publisher in the United States, is committed to making history accessible and meaningful through publishing books that celebrate and preserve the heritage of America's people and places.

Find more books like this at
www.arcadiapublishing.com

Search for your hometown history, your old stomping grounds, and even your favorite sports team.